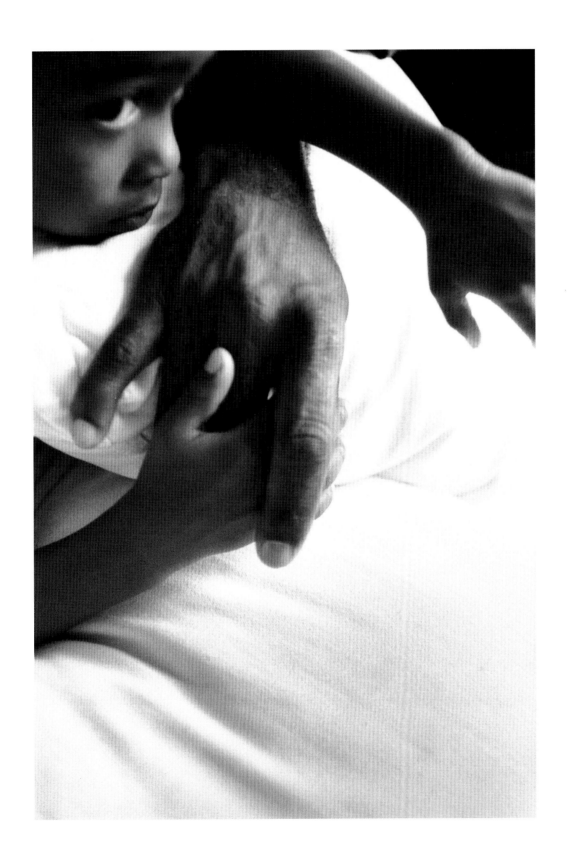

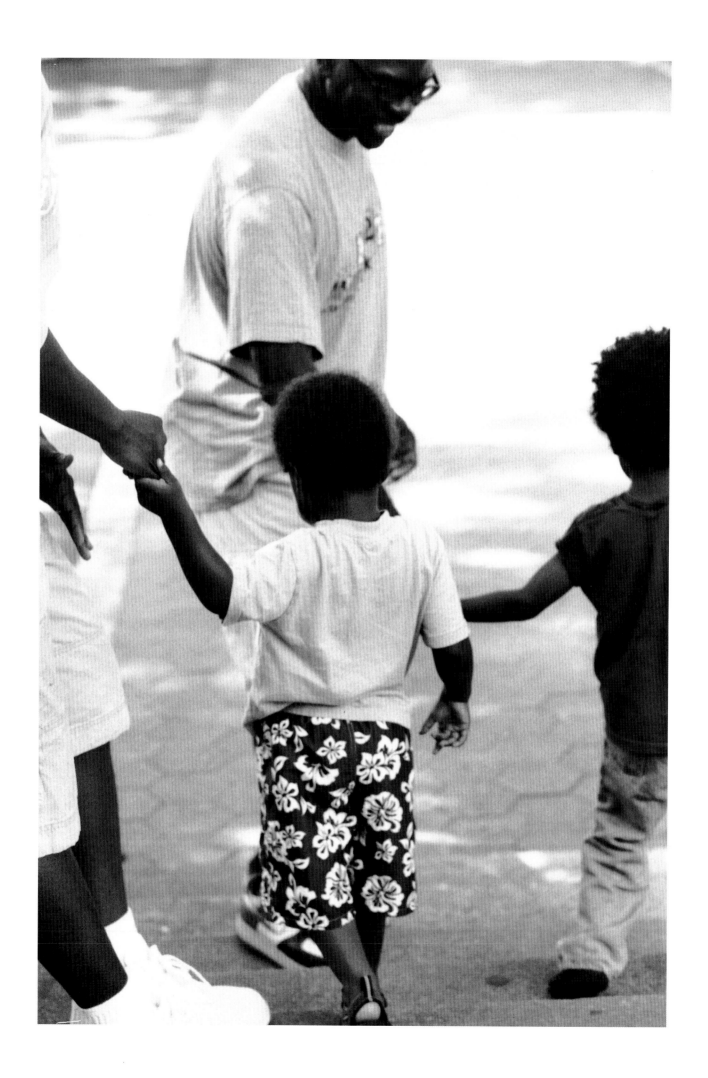

POP

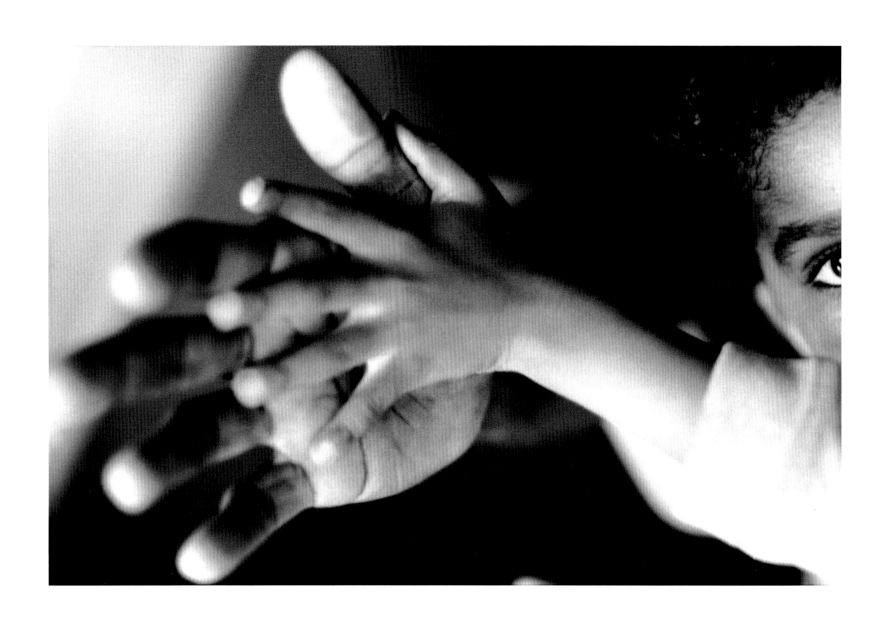

POP

A Celebration
of Black Fatherhood

Carol Ross

Foreword by Samuel L. Jackson

Stewart, Tabori & Chang | New York

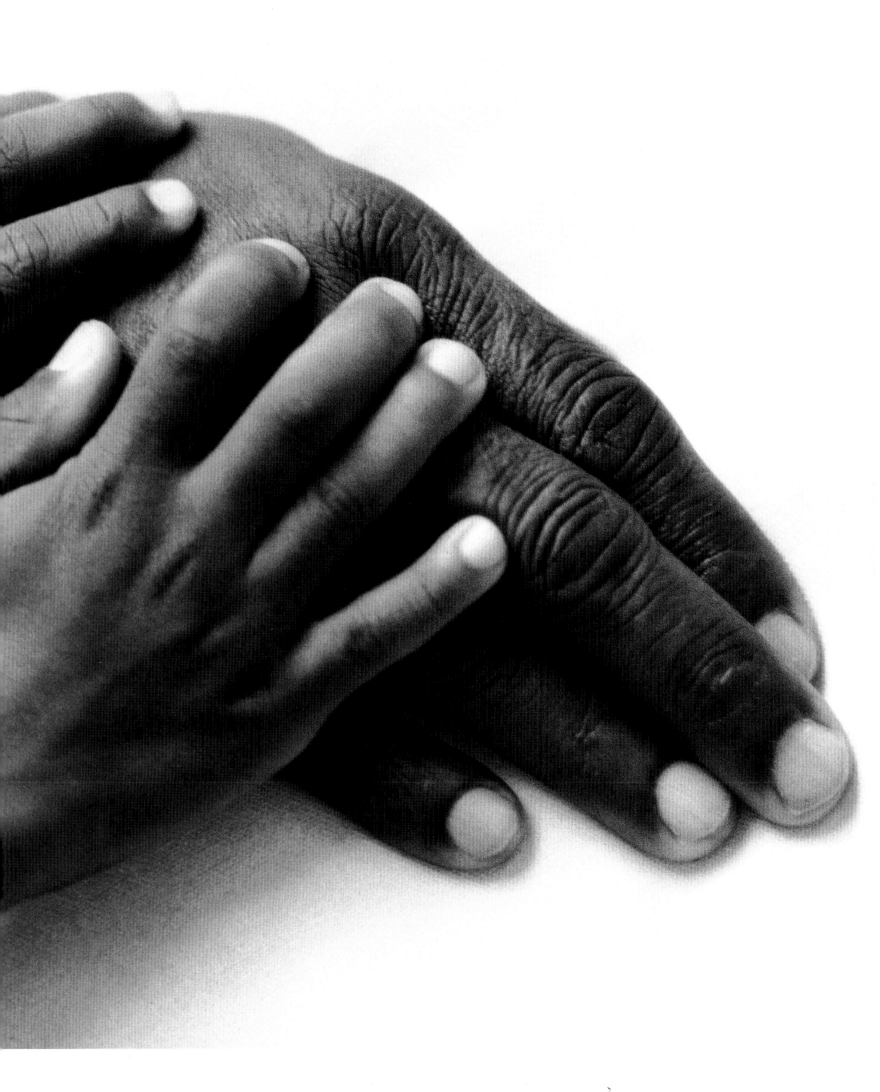

Published in 2007 by Stewart, Tabori & Chang
An imprint of Harry N. Abrams, Inc.

Copyright © 2007 by Carol Ross

Page 40: Excerpt from *The Prophet* by Kahlil Gibran, copyright 1923 by Kahlil Gibran and renewed 1951 by Administrators C.T.A. of Kahlil Gibran Estate and Mary G. Gibran. Used by permission of Alfred A. Knopf, a division of Random House, Inc.

Library of Congress Cataloging-in-Publication Data:

Ross, Carol
Pop : a celebration of Black fatherhood / photography by Carol Ross ; foreword by Samuel L. Jackson.
p. cm.
ISBN-13: 978-1-58479-598-8
ISBN-10: 1-58479-598-0
1. African American fathers--Portraits. 2. African American fathers--Biography.
3. Fatherhood--United States--Pictorial works. I. Title.
E185.86.R64 2007
306.874'208996073--dc22
2006022336

Editor: Dervla Kelly
Designer: Jasmine Parker
Production Manager: Anet Sirna-Bruder
Photographs hand printed by Jim Megargee of MV Labs New York

The text of this book was composed in Helvetica Neue Light and Helvetica Ultra Light

Printed and bound in China

10 9 8 7 6 5 4 3 2 1

HNA
harry n. abrams, inc.
a subsidiary of La Martinière Groupe

115 West 18th Street
New York, NY 10011
www.hnabooks.com

Nothin' like my pop in brown

wrapped around my psyche,

woven through the fabric of my place in space,

pulling at my potential like a rocket

to beyond dreams.

Carol Ross

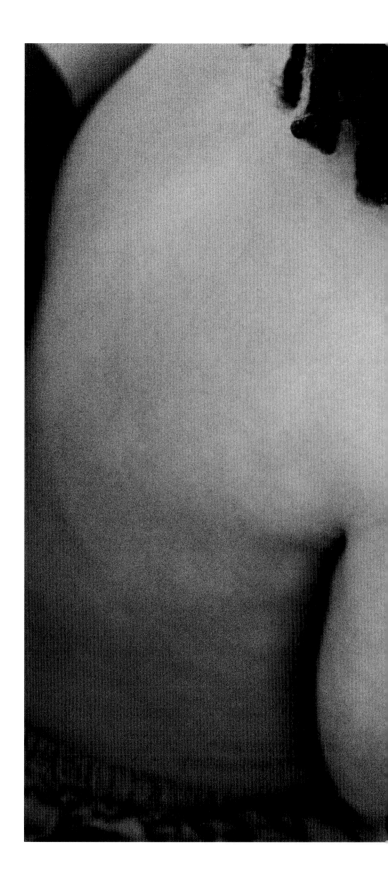

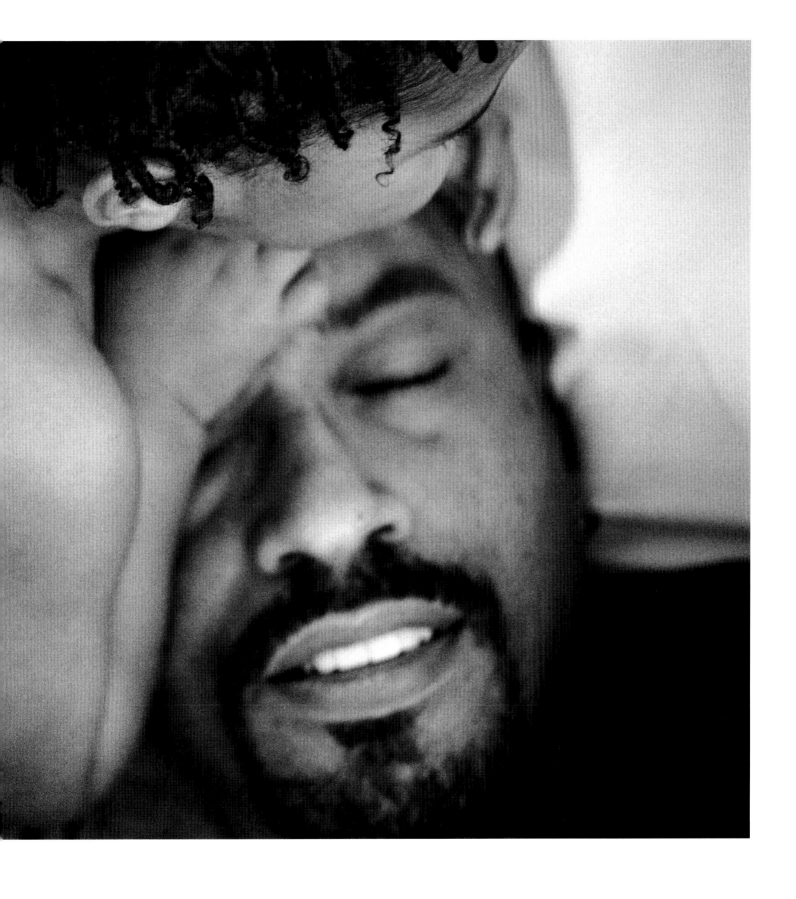

Foreword
Samuel L. Jackson

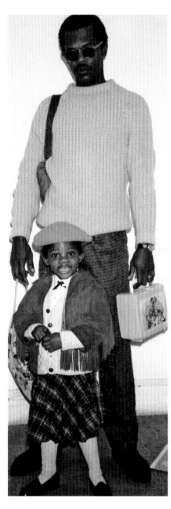

My daughter taught me everything I know about being a father. I learned from her that no matter what is in your past, your children are right here in your present moment, looking up at you, calling you "daddy," needing you and you needing them.

Growing up, my father wasn't there and so I didn't have positive thoughts about being a father. The goal was "don't get anyone pregnant" because the things I remember understanding about being a father, or what I perceived to be a "black" father, came from looking around my block. Many of the men I saw, I did not want to be and some of those images that I was exposed to made me glad I didn't have a father. If a phone call came in the middle of the night and my mom hung up crying, I would instinctively know that it was "the dad," calling to make himself feel better in some strange way. It just made me feel *not* good and I would immediately understand that I didn't want to ever be that kind of guy. The exception was my grandfather. As the only two men in my house, I got to hang out with him. He provided a safe haven and a different view of the world. He talked to me about where he and his brothers came from and how he had to negotiate his way through segregated Tennessee. I saw how he was treated as a black man and I watched him do what he had to do to survive. He also explained to me what I had to do to survive in my environment.

When I found myself married (like I woke up one day and said, "Damn, I'm married with a baby"), it occurred to me that I didn't know what the hell it was all about. However, I had an ace in the hole—my wife, LaTanya. She said, "Brother, we're going to make it

up. All you've got to do is be there." Okay, so that sort of became my mantra. "Be there." Here was this beautiful child looking up at me and all I had to do was "be there." Well, it was certainly worth a try. So, from the age of three months, my daughter, Zoe, traveled all over the world with us from one performance to another. If we were on the road, she was on the road. We packed a lot of crap and lugged it around from city to city, including a bed because LaTanya was paranoid about Zoe sleeping on the hotel beds. (Yes, it was insane!) But there is something about being everywhere with your child that creates an indestructible bond. Everything about you changes and you watch as her needs become one with your priorities. Through the process of "being there," I've gained an unparalleled respect for myself as a man. My daughter has come to count on me and it feels good. I became present doing dad things, and after all, I realized that it wasn't as hard a job as I had imagined or projected. All a kid really wants is your hand, your lap, some kisses, your love—to protect them and be there for them. I was a father and I liked it.

Piece of cake, right? Not quite. There were some very rough days and challenging times that also came with this process of being there. Though all of the things I had figured out just from being around Zoe became such a part of me, I was still trying to figure out who "me" was. Doing drugs and drinking provided an escape, but something deep in me kept pulling me back. I still knew that I had to function *and* be a parent. Looking back, no matter what my messed-up state was, I thank God that I never put my daughter in jeopardy. Now LaTanya may disagree, but it's true. That bonding thing that had happened between us kept me there, and even back in the worst days, I still found a way to function as a parent. When Zoe first started going to school, her nursery school was a walkable distance from our house. But on some days, if it was too cold, she and I would ride the bus. Now, Zoe had seen people put their hands up and catch a cab before. On some of those really cold days, she would just reach out and put her hand up—and cabs would stop! I would look at Zoe like, "Do you have the money!?" and then I'd look at the cab driver like, "Does she look like she's got money? You didn't see my hand up!" But I'm steadily getting in the cab and using the money to take a cab that I was going to use

to buy some drugs with. I'd figure, "Well, I'll get some money from somewhere." Because if that was her wish, then it was my desire to make that wish come true—regardless of what I was dealing with. I was still connected to my child and she was a big part of me. I still had to be a provider of some sort and I did everything I could to do that, but there were also times when Zoe had to take the lead. Some days, she would come downstairs, punch me and say, "It's time to go," and I'd get up, get on the bus and ride to school with her. On those days, she had to be grown-up. On other days, we'd hang out, talk, go to the park—I'd push her on the swings, put her in the sandbox or on the sliding board—that's just the way we were together. No matter what day it was, I remained open and honest with her. She knew something was off, but she didn't know what it was. When she and LaTanya came to rehab, part of my recovery was to stand there and say to them that I was an addict. I don't know if Zoe grasped it, but she knew that I was in a place where something was supposed to change when I got home ... and it did.

Everything that happens, happens for a reason. I'm *not* saying that every father on drugs can or should function as a parent. Every father and every situation is different. What I am saying is that being a father is not about being perfect. When you're there and if you continue to fight through it, there is an opportunity to create stronger bonds. You know that all of you came through something together and made it work. That's harder to do when you're not there. My daughter didn't know what her part in that was. She just wanted to be a kid, but the reality is that she was a part of it and the reason for our family's recovery. We're stronger because of it and she's stronger because of it. I think all of us have it within us to be better parents, but life happens and people get turned in different ways. Even something as fundamental as making sure that your kids have enough—meaning there might be days when they eat more than you, because they need to grow—is something, as a parent, you just understand. There are some people who don't understand that or don't do that kind of thing because their main focus is on whatever has got them turned around. Other people do understand that, because they're just driven in a certain way that makes them want to be a good parent, no matter what the circumstances are.

One thing I learned from being around my grandfather is how important it is for black men to explain to their kids that the world is not always going to be a level playing field for them. Whether they want to believe it or not, it is our responsibility to give our children the information. Something in my bloodline contributed to my being an addict. That may not happen to Zoe but I gave her the information anyway. I explained to her that if she's drinking and doesn't remember what happened the night before then maybe she doesn't need to drink. We have to give them all the tools we can so that they're armed when they go out there. Even if they don't use them all, they still need to know that they've got you and that you've got their back.

Although everybody has different aspirations for their kids, parents have to have realistic expectations. Those trying to find a way out of their situation through their kids are only doing them a disservice, but if it's the only thing they have, the only way to do that is to educate them. Don't just make sure he can dribble left-handed or that she's faster than the kid down the street and that's it. Is she smart? Is he going to school? Even if he's been groomed for the NBA his whole life, and he never gets drafted or he does get drafted but he breaks his ankle and never hears his name and a million dollars mentioned in the same breath again—he's still got his education. Nobody can take that away from him. We have to make sure our kids get educated. That's the only way any child is ever going to compete with the people running this world. And if we don't do that, we're doing them a disservice. And that's black, white, brown, yellow—whatever. We always want to have the excuse that somebody's holding us down. Step right up there and do it.

Being there with Zoe taught me that kids need a father. It also taught me that fathers need their kids. I wouldn't have figured that out if I wasn't there. Even if it really does mean making it up as you go along—just be there. And when you're gone, please make sure you've done something to insure your child's future as well as you possibly can, so that your kid can have something. Even if it's just a damn insurance policy. Don't leave them burdened. That's what parenting is for.

Hey, I'm Samuel L. Jackson—Zoe's dad.

Introduction
Carol Ross

My son was born at 5:07 a.m. on what couldn't be a more perfect May morning. His father was on him like a second layer of skin, eager to cut the chord and whisk him into his arms. Our child stared into his daddy's eyes and quickly stole his heart like a thief in the night. As my tough-as-nails spouse metamorphosed into a warm gooey mound of melted chocolate, he looked back into his son's eyes and whispered, "Break the cycle. Break the cycle."

His desire to break the cycle came to him honestly, as his strongest memory of his dad was when he was eight. His father pulled up to the corner and said, "I'm your dad." He bought my husband a hamburger then sent him off to school. That was the last time he saw him. Sadly enough, my husband is not alone and there are many similar or worse stories about experiences with fathers. *Yet*, there are also positive stories about fathers who are committed to being present in their children's lives. *Many*! Too many to continue to ignore.

Watching my son grow, I noticed how his connection to his father was transforming as he began to rely on him more for validation of his own identity. Whether wanting to go with him on errands or walking around in his dad's big floppy shoes, my son was beginning to imitate him. With this realization, I recollected the validation I had received from my own father. With a heart of solid gold and the patience of growing grass, my father lays claim to a brilliant mind and a wacky sense of humor. He provided me with more than enough tools to face the world with wonder, anticipation, strength and laughter. Without exception, he demonstrated the importance of exploring all possibilities of everything with an open mind to gain a proper perspective. He surrounded me with a natural love of my skin in an environment that didn't look like me. He supplied my validity in a color-conscious world predicated on invalidating. And he gave me turkey sandwiches and Yoohoo while sitting at the counter of our favorite deli. He carried me around on his shoulders, played "grab like a crab" and tickled me silly. He drove me to school *every* morning, dug in my ears if he suspected wax and unfailingly answered every one of my thousands of questions. He gave me the one thing that mattered most—himself.

Pop began as a natural appreciation for the love I have for my father and for my husband as my son's father. Initially, I simply wanted to acknowledge black men who are present in their children's lives. I also thought of my husband's father and wondered what the circumstances were that kept him away. Perhaps *Pop* could also provide encouragement and support for other fathers who desired to "break the cycle." But to my surprise, during the process this simple act of acknowledgment and encouragement became much more. While too many magazines and newspapers that mentioned black fathers seemed to focus on their absence, it appeared to me that everywhere I went black fathers were present—taking their children to school, playing catch with them in the park, hugging and kissing them. Every mention of *Pop* spawned numerous stories of great black fathers—someone's brother, neighbor, son, father, uncle, nephew, friend, that they swore was an excellent father. Though I don't doubt the accuracy of the percentage of absent fathers, I often wonder why the focus rests on them, while the great many who are present remain unacknowledged. As I moved further in the making of *Pop*, I became more keenly aware of the disregard that society has for black fathers, even when they do get up every day and find ways to make better lives for their children. This sense of isolation that is so prevalent for many black fathers, having to function in such a non-supportive environment, became the reason *Pop* had to be much more than an acknowledgment.

An affectionate term my daddy used to call his daddy, "Pop" is what many people called their fathers, and often other people's fathers, back in the day. Sometimes community mentors were also called Pop. I still hear countless stories of people and children today that refer to the men they care for as Pop, and although the name still retains a certain level of love and respect, its value, as it pertains to black fathers, has changed significantly over the years. Time and circumstance has conditioned us to be angry with black fathers or give up on them altogether, sometimes only because they may not represent what we are taught they are supposed to be. We are seldom taught to understand them or given the tools to work with them. I believe that behind every individual, there is a story, a reason and a trail, which we all contribute to in some way.

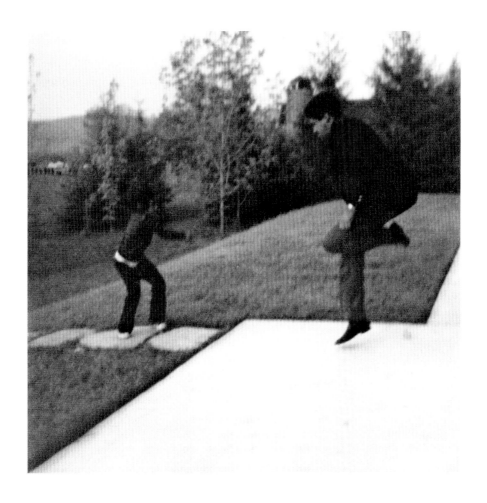

The fathers in *Pop* come from a variety of circumstances, but no matter their situation, they've embraced their children. Some of them are raising their children alone, some share custody, some are married or are raising children from several marriages. Some are celebrated or wealthy or struggle daily to make ends meet. Some play key roles in huge corporations and some work from home. Some of these fathers were raised by their fathers, some by men who were not their biological fathers and some have never met their fathers. Ranging in age from the mid-twenties to seventy-four, the fathers in *Pop* are all different and from varying backgrounds, but they are all black fathers whose children are very blessed to have them. Photographing these wonderful dads for *Pop* revealed within each his own unique approach to parenting, and, as you will find in their own voices, a true diversity of style, rhythm, thought and approach. Yet, there was something else they all had in common. Within the subtlety of these expressions of love for their children they all equally showed an intense vulnerability to them. We are often overwhelmed with images of black men as unusually serious, angry or tense—or, at least that's the interpretation—but what I experienced with all of them was quite the opposite. I saw gentle, fragile hearts, carefully guiding the spirits of their young with the strength and foundation of steel. I saw great fear and sometimes desperation hidden behind calm composure, especially from fathers raising teenagers. I saw hope and anticipation from those with infants. I saw fatigue and sleep deprivation from those who nonetheless mustered enough energy to chase, laugh and play. I saw books being read, alphabet songs being sung, pancakes being cooked and little teeth being brushed. I witnessed bible readings, serious discussions, debates and disagreements. I watched, I captured, I learned and then I left—my heart always warmer and my spirit much wiser.

What began as an acknowledgment of the few became a celebration of the many—the joy in understanding that if we stop, listen and take a closer look, we will see that there are many blessings to count. We'll see the fathers who are there, including the men who take it upon themselves to be like fathers. We'll be inspired to uplift and support the fathers who aren't there, but want to be, and we will certainly pray and hold a space in our hearts for the ones who can't be there, for whatever reason, whether physically, emotionally or mentally—because if they could, they probably would.

There are black men out there breaking cycles every day. We just don't hear much about them. In celebration of these fathers and all fathers and all little boys who will one day grow up and become fathers, I present *Pop*.

On the day that this photo was taken it was only seventeen days after the funeral of my father, Bobby Jackson, Sr., whose life was claimed at sunset on August 29, 2005, as a casualty of Hurricane Katrina. He will never know that I am the father that I am because of the father that he was. I never had the chance to ride a bike with my father, and I pray that that my son will grow to be a more responsible husband, father and protector of his community than my father and I. My daily actions breathe, eat and sleep the positive enrichment of young black men, for whom without the direction of our fathers, grandfathers, brothers, cousins and uncles we will remain confused and lost. I raise my son so that he can grow straight like a tree! And so that his branches will create generations of strong, healthy, nourishing fruits.

My greatest fears of being a father came to realization on August 31, 2002, the day Kairo Omar Jackson was born. I was probably more scared than him and I was already here for thirty-one years. Isn't that ironic? And I was a grown man. My feelings quickly changed when he grabbed my finger and looked at me, as if to say, O.K. Dad, I am here now and where do we go from here? The rest came naturally. Men are made to be protectors of our sons. When we step away from that, we are acting contrary to our nature and are taking a first-class ticket to our own self-destruction. Me personally I like the D "Dad" train. It fits me like a pair of new kicks.

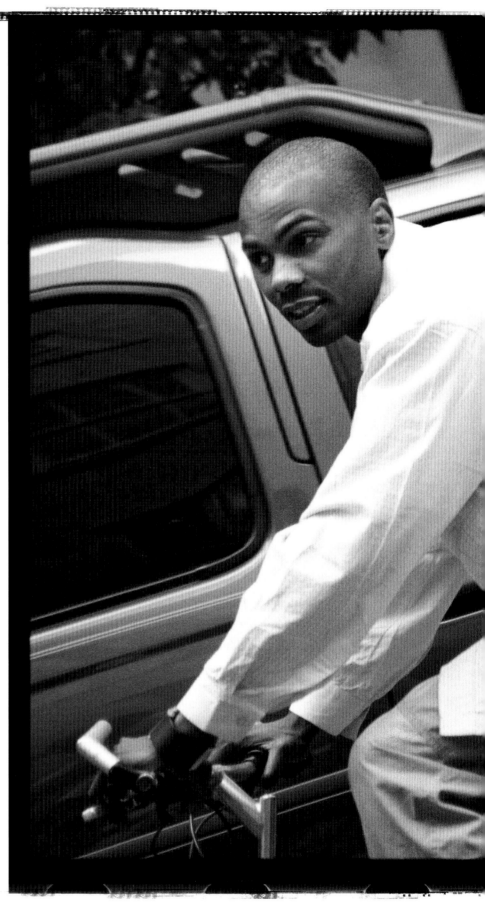

GORDON

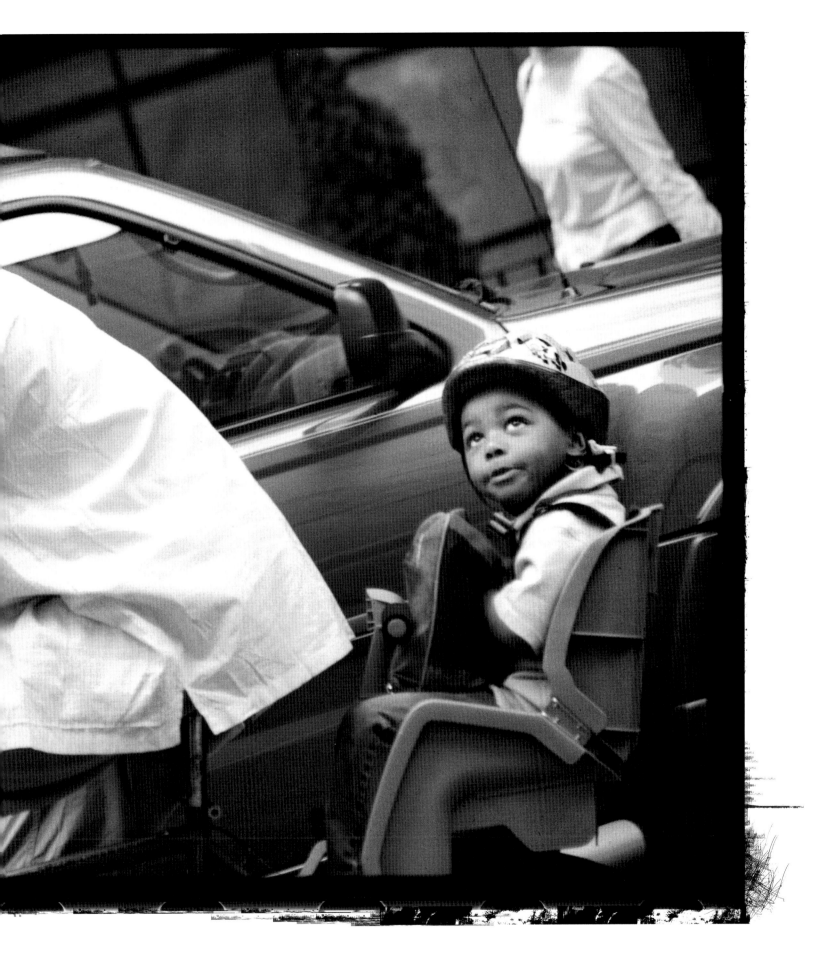

Raise Your Children!

Don't coddle them.

Give them the tools to succeed.

To believe that every day is a blessing.

To think before acting.

To know the power of love and respect.

To know that love doesn't have to hurt.

To have pride in hard work.

To tell the truth.

To be good people.

Not to sell themselves short.

To keep life simple.

Raise Your Children!

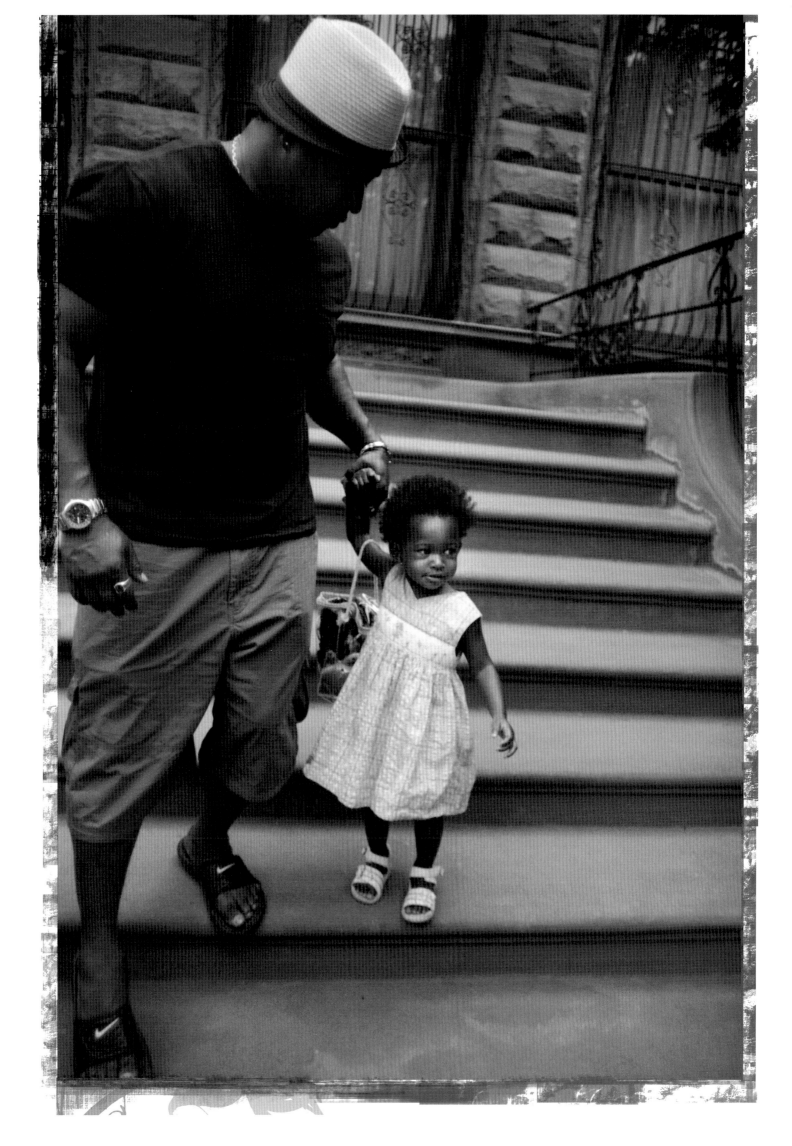

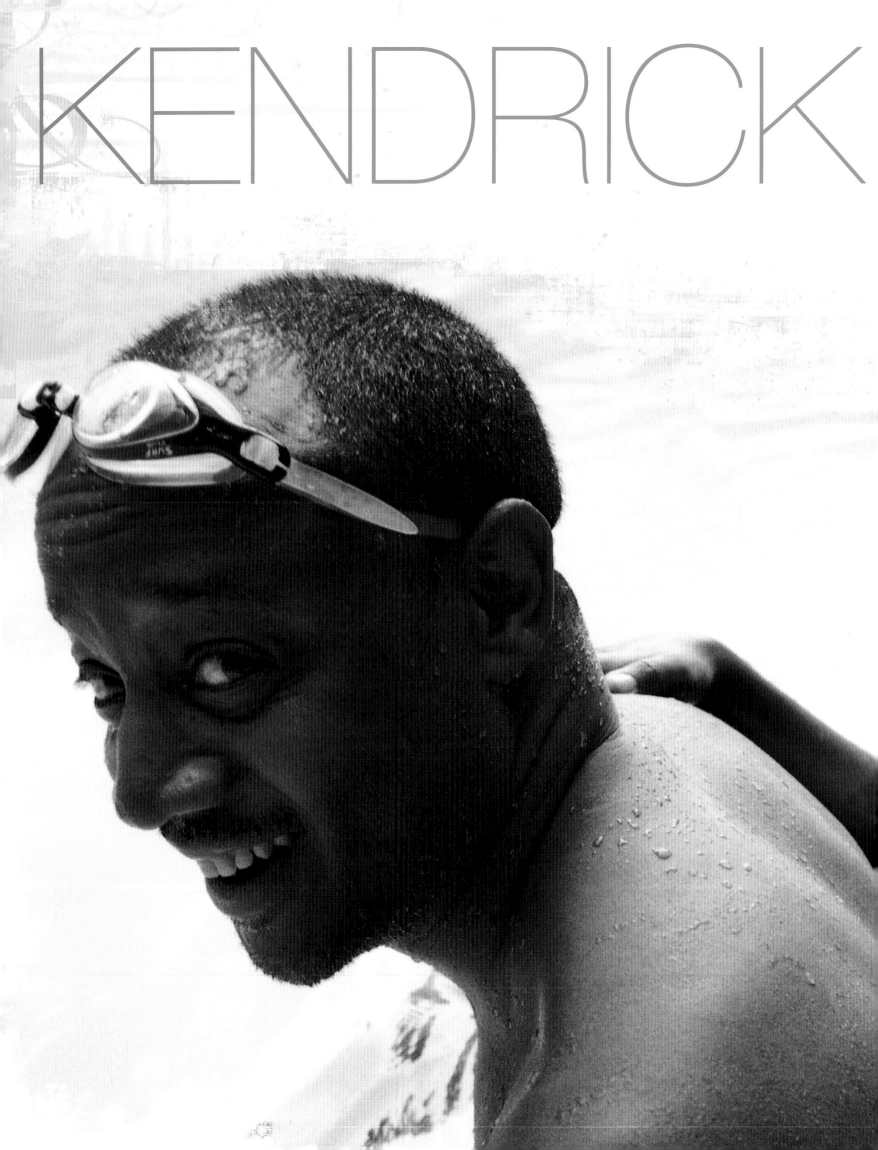

KENDRICK

A father is the person that sets the tone, builds the foundation and opens the eyes of his son or daughter to what the real world is like. When the child knows what the real world is like, the child will not be afraid of tomorrow, because the father has equipped them with everything they need to make it in life. The father has taught the daughter how to choose a companion. If the man does not treat her like her father treated her, she will know that he is not the right companion.

The son will know how to treat women with dignity and respect. The son will be able to identify women who do not mean him any good. The son will work and do what he has to do, because that is the example that the father has set before him.

With a smooth tone, solid foundation and eyes that can see beyond tomorrow, this is what a father passes on to his children.

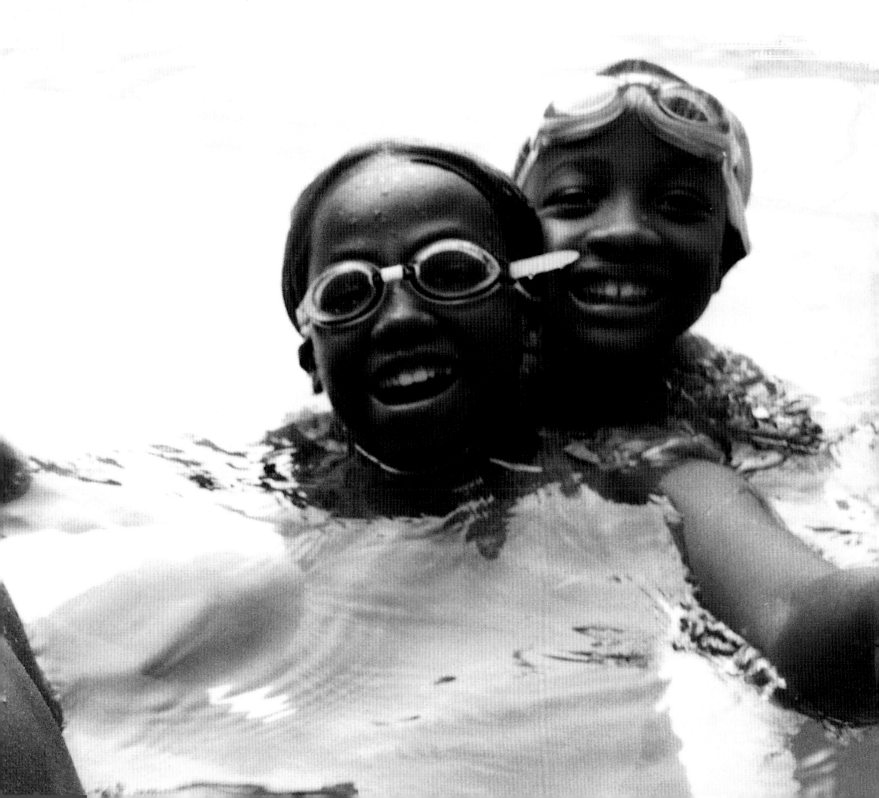

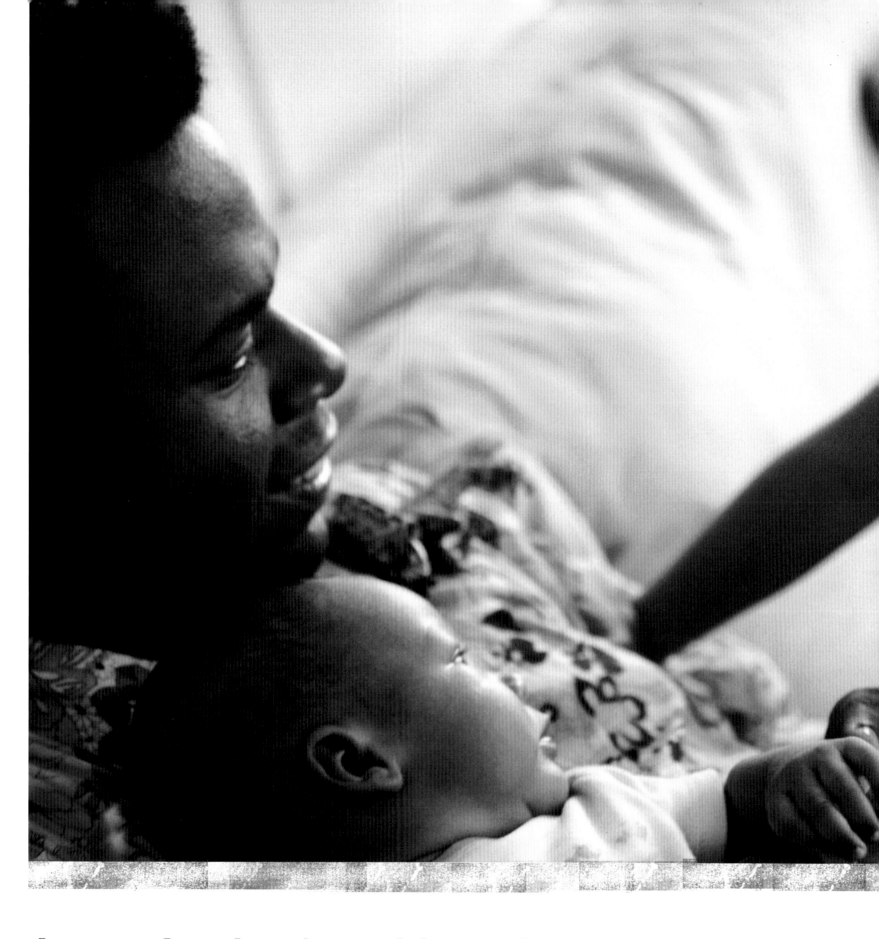

MALIK

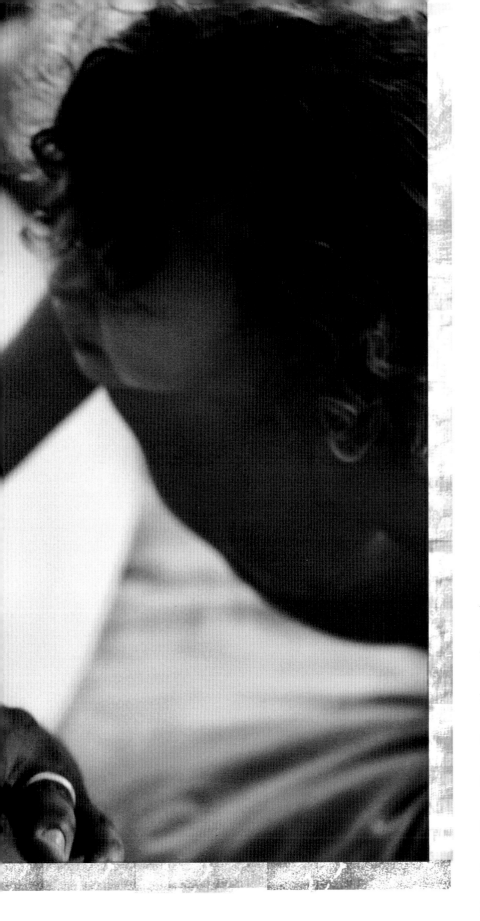

The one thing I would like my children to take from my experience is to try to always be a free thinker. Even though being one can be a little crazy, especially in this time when people seem to be closing ranks. The "us vs. them" mentality is all around us. Having a family composed of different cultural and national identities can be challenging, but it is a challenge I embrace wholeheartedly. Art, music and culture brought my family together. It is our lifeblood and can still unite people in the right hands. One love.

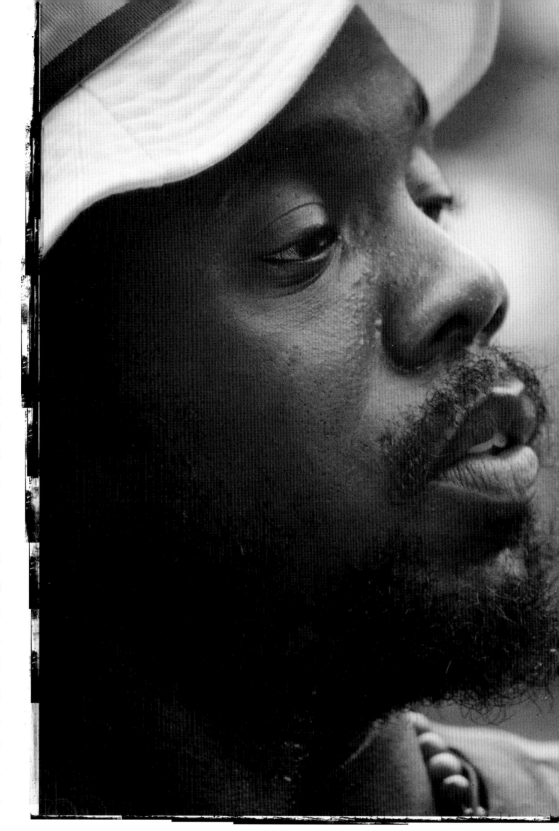

I became a father because I wished never in life to be engaged in a meaningless task. Fatherhood guarantees that. Reward? I have learned what devotion is all about. Never in my selfish existence did I run toward a human being in gut-wrenching anguish and stick around long enough to see them brighten, flower and triumph. The challenging part of fatherhood is staying conscious and deliberate in all your many dealings. I take time to reflect on my actions and hold myself accountable . . . eventually.

My father is a real tough guy, not very expressive. I try to be tough when it is necessary, but I mix in more tenderness. Black fathers are perceived as absent and/or irresponsible. This doesn't affect me at all. F--- 'em. My parenting style is evolving. I try to establish boundaries without building impenetrable walls. The answer might be no, but I'm open for discussion. My child is uniquely blessed with a wellspring of inner strength. Go girl. Children need real engagement. No patronizing, half-listening stuff. They are too smart for that.

The key to being a successful dad is a balanced mind, body and soul. The demands will knock the strongest, richest, most handsome cat off center. My daughter expresses total loyalty to my wife. It warms my heart . . . and breaks it at the same time.

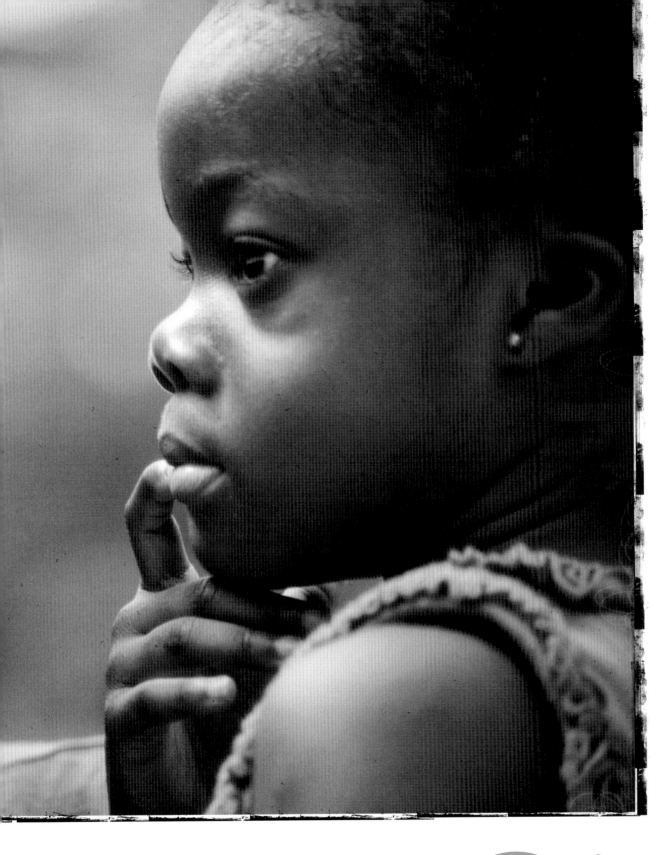

DOUG

Fatima is the truest blessing. The joy I feel when she wants me to hear a new song she's learned, see a new dance move or just watching her grow into this incredibly decisive little person, is many times overwhelming. As a father I want to protect her from all that is wrong in the world, yet let her find her own way. Being a father now makes me appreciate mine even more and I want to do more than my best. My daughter makes me smarter and her smile makes me grateful.

IBRAHIMA

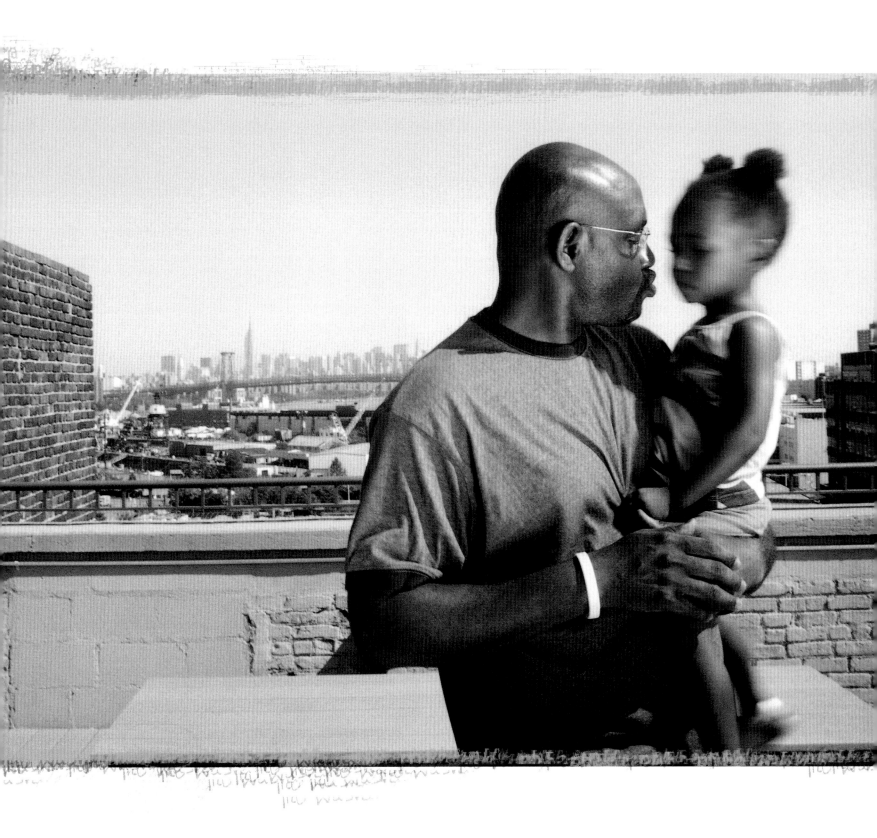

My internist wants me to take another two prescription medications. It was a big ego blow two years ago when I, just over forty years old, heard the same doctor decree that I had hypertension, high cholesterol and borderline diabetes. I had given in to the high blood pressure and cholesterol-lowering medications, the baby aspirin and, most importantly, the diet and exercise regimen.

You see, I was thinking of the four little children that were counting on me to be around for a good long while. I followed the dietitian's program with messianic fervor, dropping thirty pounds and ten years in appearance. However, in recent months my fidelity was not nearly as pure. Ten pounds came back, as did some of the dangerous numbers from my blood tests. So here I am again, facing the music, sentenced to glucose-reducing and good-cholesterol-raising medication.

For me, the responsibilities of fatherhood have been a revelation of the responsibilities that I have to myself. The paradox has been that the more I see myself responsible for my children, the more I appreciate those responsibilities that I have for myself. This goes beyond my physical health.

I have traveled to places I only imagined, not only to give my children the breadth of experience but to enhance my knowledge of the world as well. I remember the time when we traveled to South Africa; while approaching Robben Island, I had tears streaming down my face. I tried to relate to my children the spiritual resonance I had to the suffering that had taken place there. It had great meaning for me and I was glad that I had them with me to share it.

It is a true blessing to be a father. To provide sound and healthy examples. To see the possibilities and have great adventures. All this to share and pass on to them great hopes and dreams. This is the sacred honor of fatherhood.

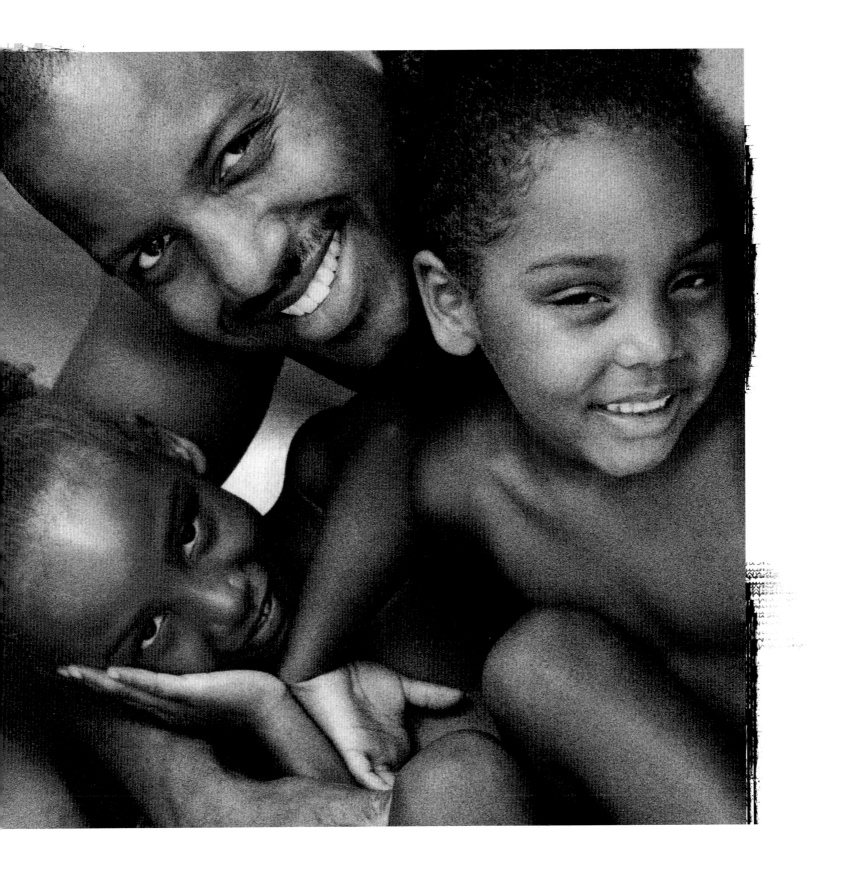

HOWARD

My experiences with fatherhood have been wonderful, from the time I sat in the delivery room watching the birth of my son to, most recently, celebrating his acceptance to Norfolk State University. There were some challenging times, but a majority of the eighteen years have been positive.

GEORGE

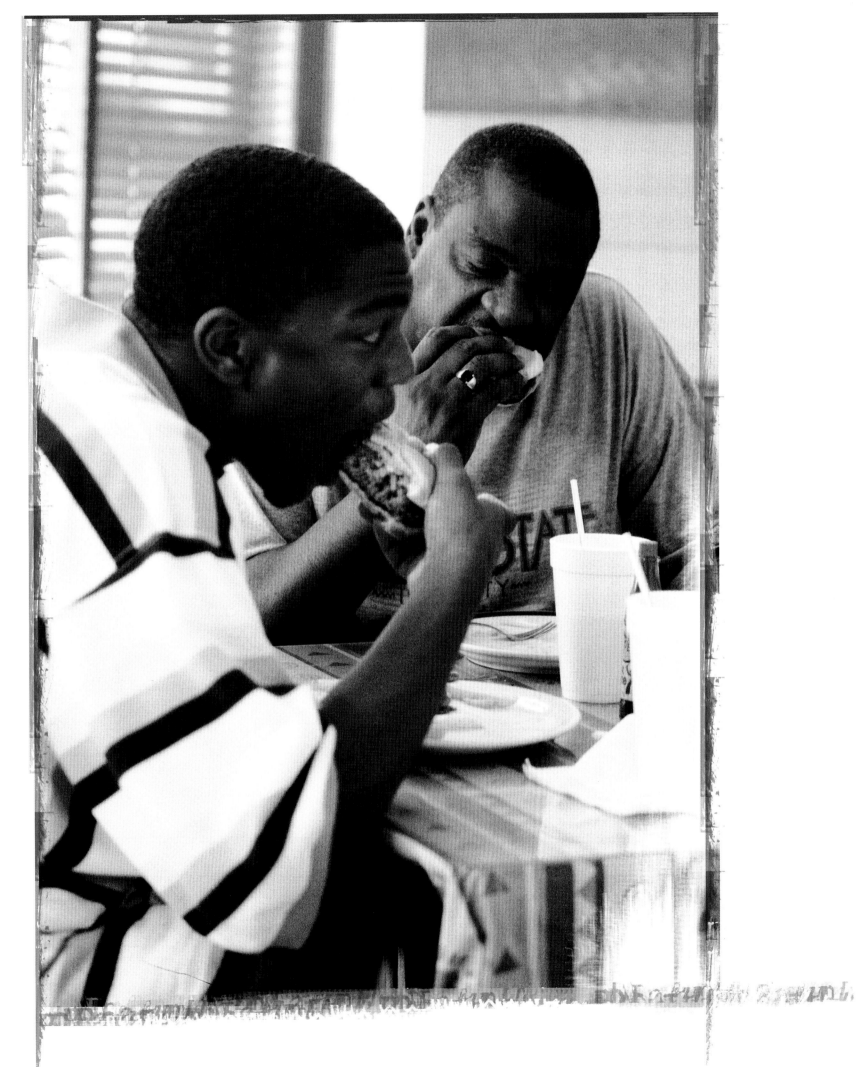

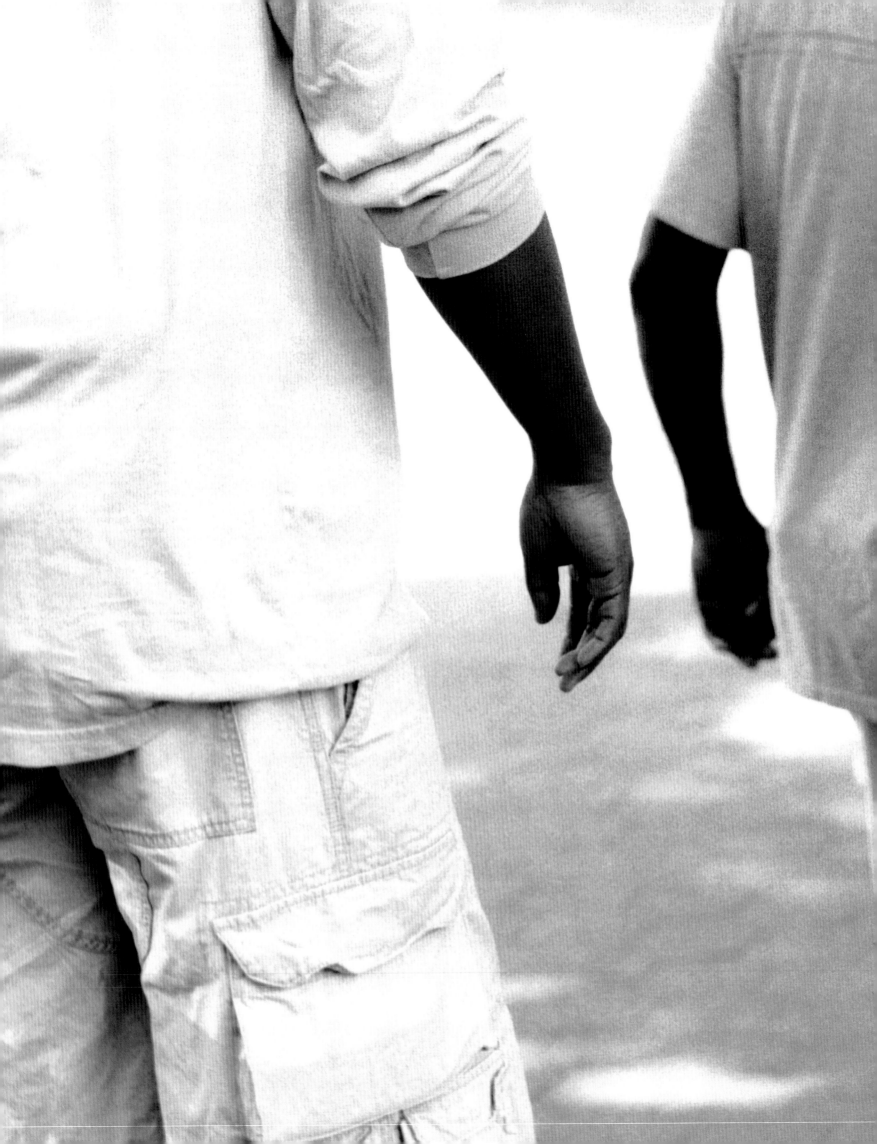

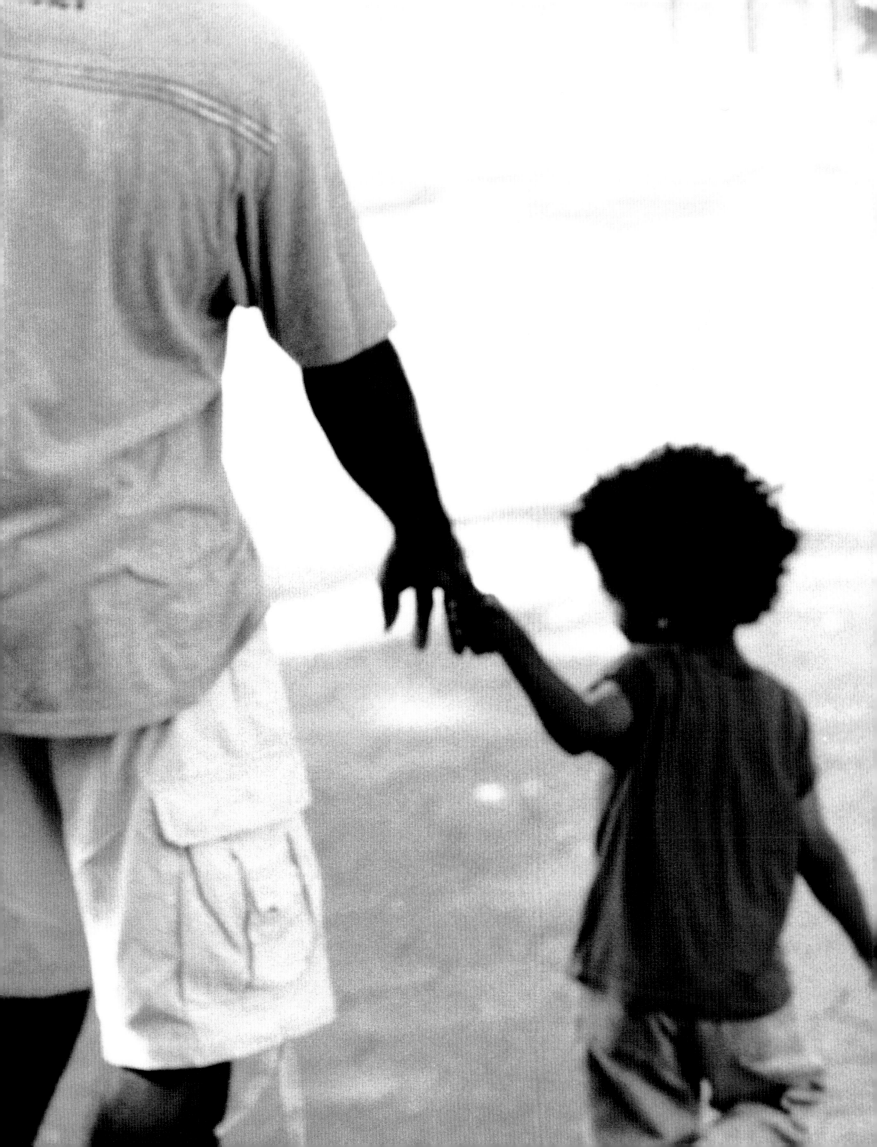

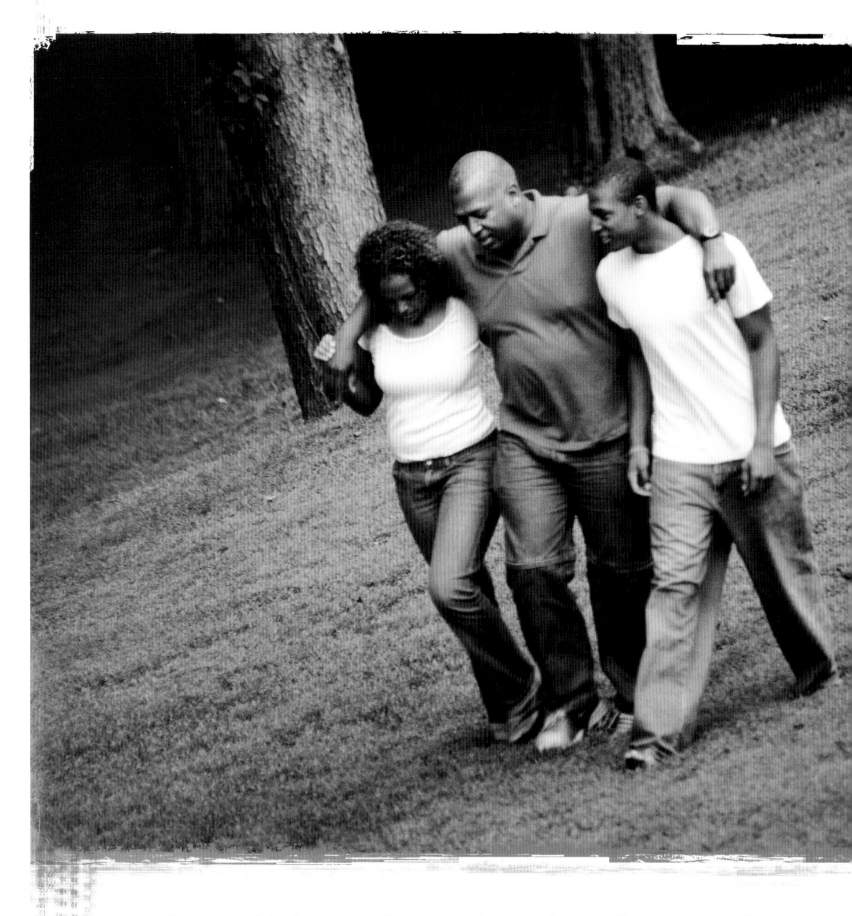

WILLIAM

I am now one year older than my father was when he died at the much too early age of forty-six. This fact has caused much reflection of late upon my own mortality. When I was nineteen years old, about a year before he died, my father said to me, "I love to just look at you." At the time, I had no understanding or appreciation for that statement. In subsequent years, I often wondered what he meant and regretted my failure to ask for an explanation. It was not until the birth of my children that the depth and magnitude of that brief and single declaration hit home. In Kirby and William's faces, I am reminded of their mother, myself, my four sisters, my brother and my parents. When I look at my children, I am filled with incredible love, hope, pride and a palpable sense of the existence of something "greater," commonly referred to as God.

Thus, I love to just look at my children.

A few months ago, I told my son, "I love to just look at you." In response to his rather perplexed gaze, I tried to explain the emotional significance of that sentence, only to realize that he too would be unable to truly fathom the words of my father until he is himself a dad. Unlike my father, I hope that I will be around to witness my children's epiphany, their understanding of the words, "I love to just look at you."

MONTY

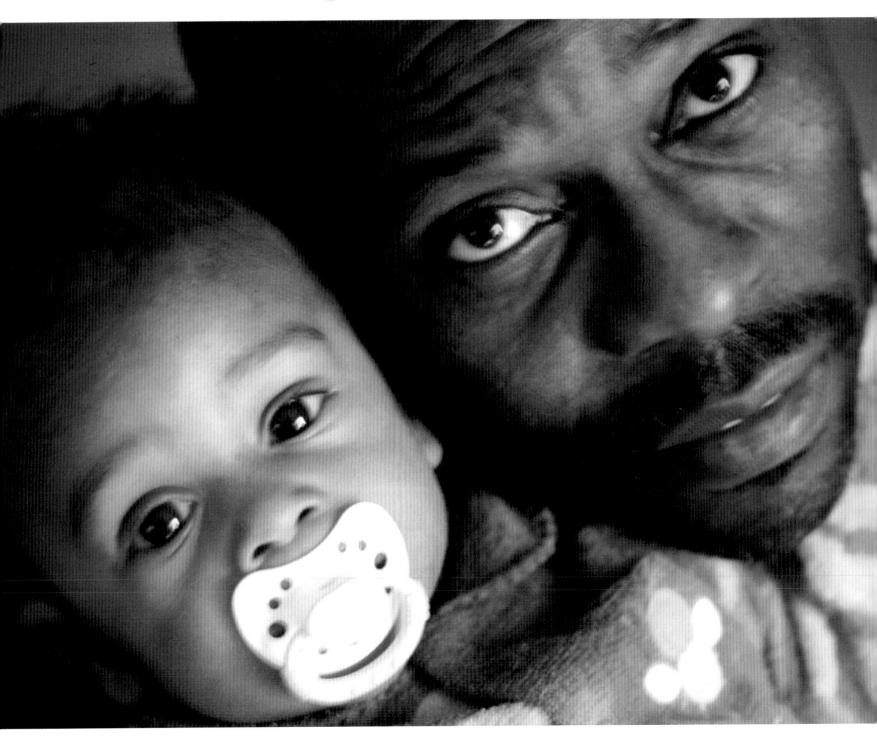

Being a father is rewarding for several reasons, but primarily because I get to experience the growth of a human being. Nothing is more satisfying to me than to watch an infant grow, develop and become. Trying? Yes. Challenging? You bet. But in all of its complexity, it is by far the best thing to ever happen to me. I wouldn't trade my fatherhood experiences for all the gold in the world.

I know my family loves me, I know my parents love me, I know God is love, but I never knew what love was

for me, until my spirit, heart and eyes first saw Haley. She is my gift from God, I am in awe and blessed to be

in her presence.

BRYAN

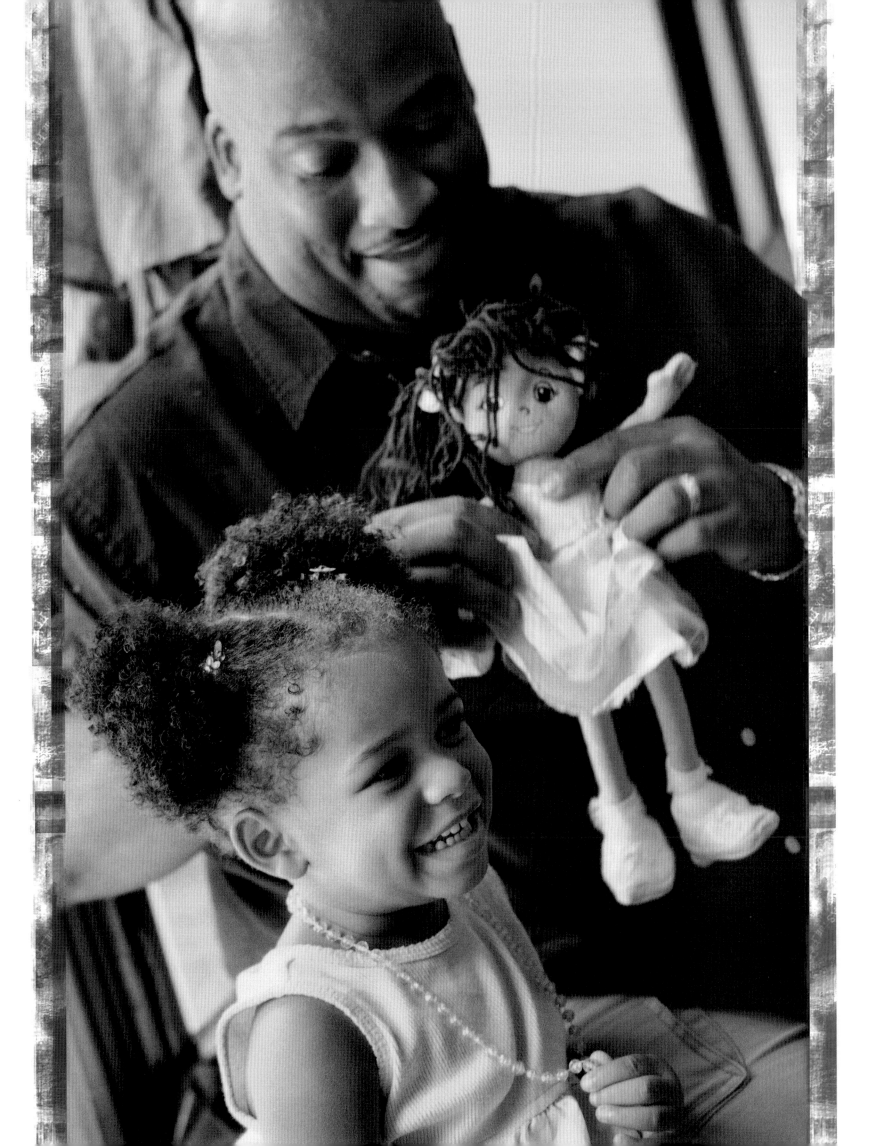

DAMANI

While attempting to come up with a personal statement that reflects how I feel as a father, I could only think to refer to the wisest words I have ever read on the subject. These are words I refer to when I reach a crossroad in parenting. They are words that I strive to embody with my daughter. They are the words of Kahlil Gibran:

"Your children are not your children. They are the sons and daughters of Life's longing for itself. They come through you but not from you, and though they are with you, yet they belong not to you. You may give them your love but not your thoughts. For they have their own thoughts. You may house their bodies but not their souls, for their souls dwell in the house of tomorrow, which you cannot visit, not even in your dreams. You may strive to be like them, but seek not to make them like you. For life goes not backward nor tarries with yesterday."

excerpt from *The Prophet* by Kahlil Gibran

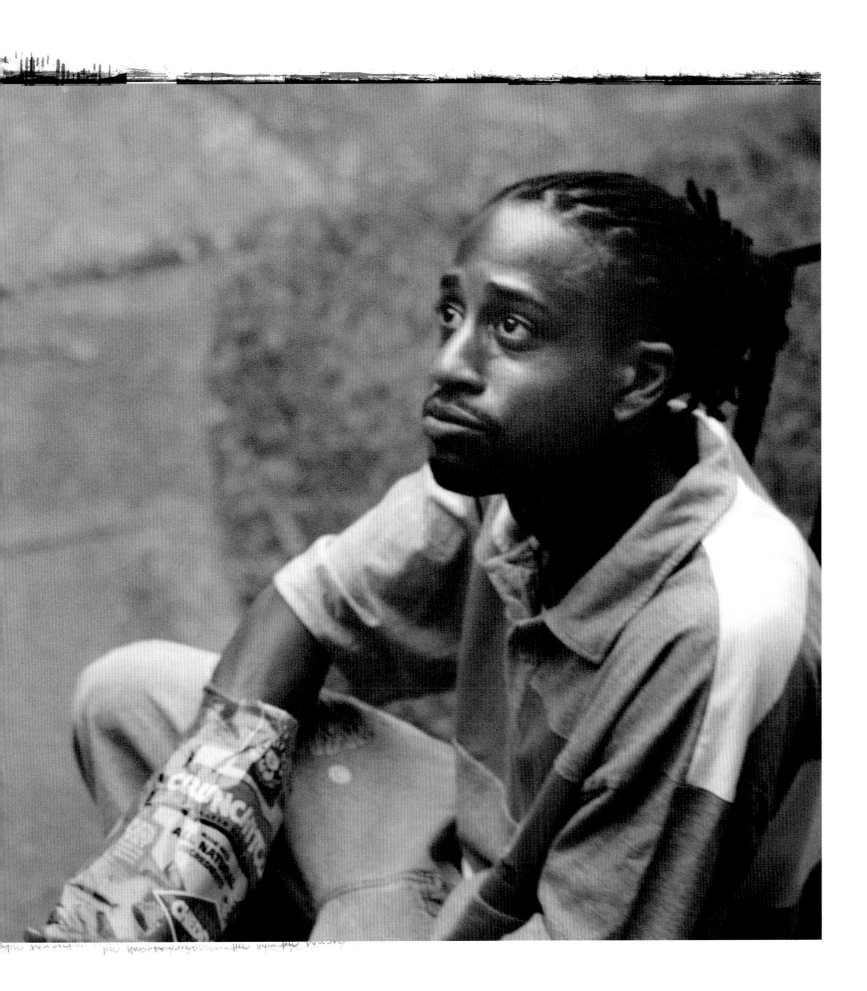

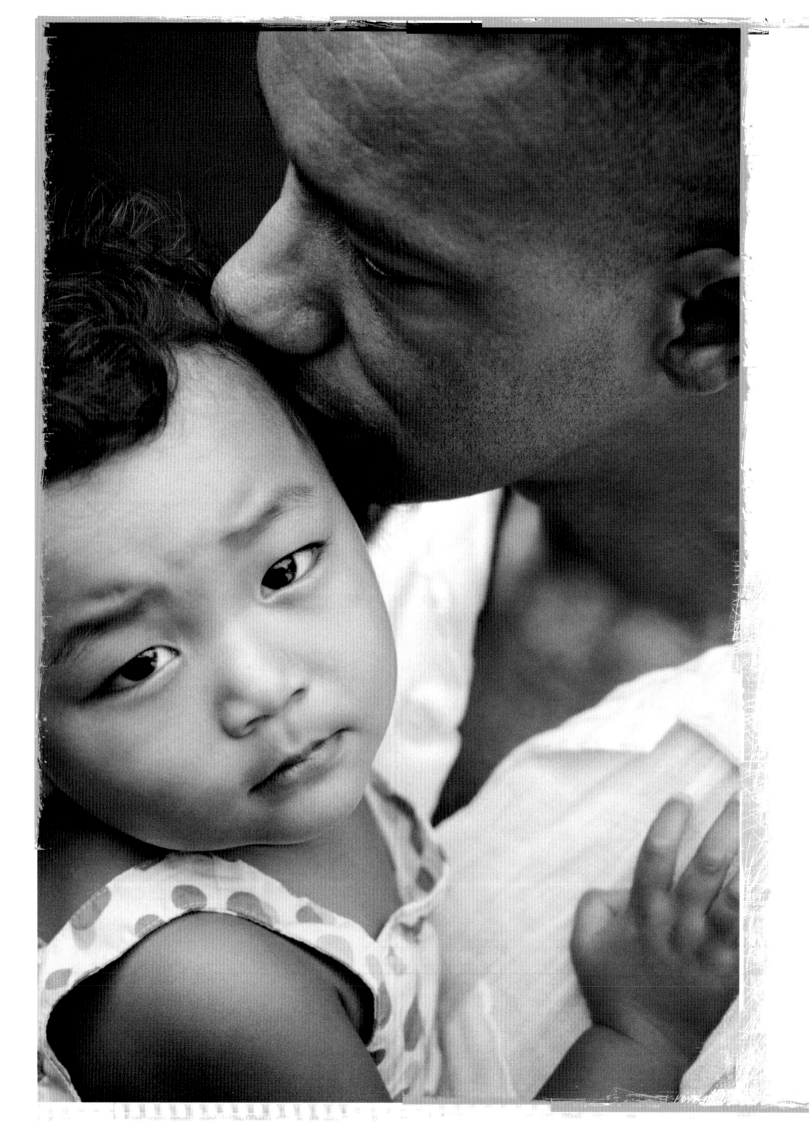

Cooper makes us laugh a lot and brings joy to every day. A father is a coach for life.

ROGER

When I sense danger near him, I become a lion. When he

sits up on my shoulder and plays with my hair, I feel like

Hercules and Mr. Potato Head all at the same time. It's

amazing how you'll become anything you have to be to

keep the little one safe and smiling.

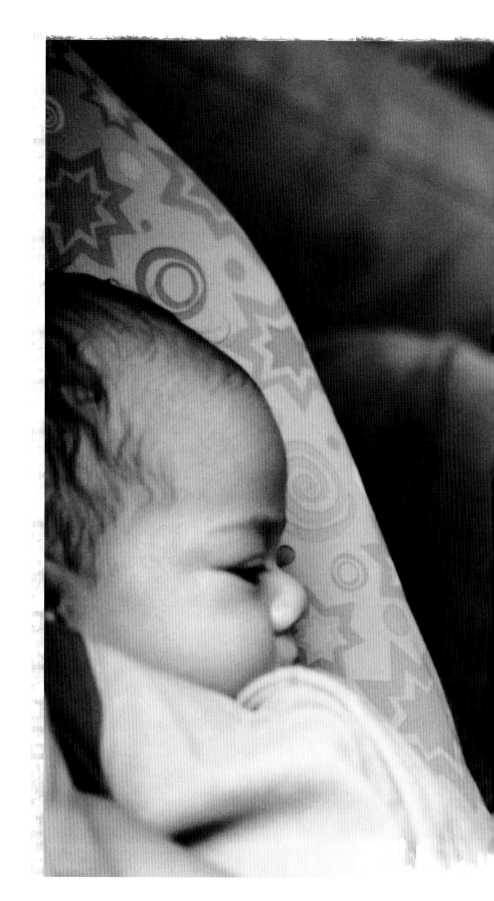

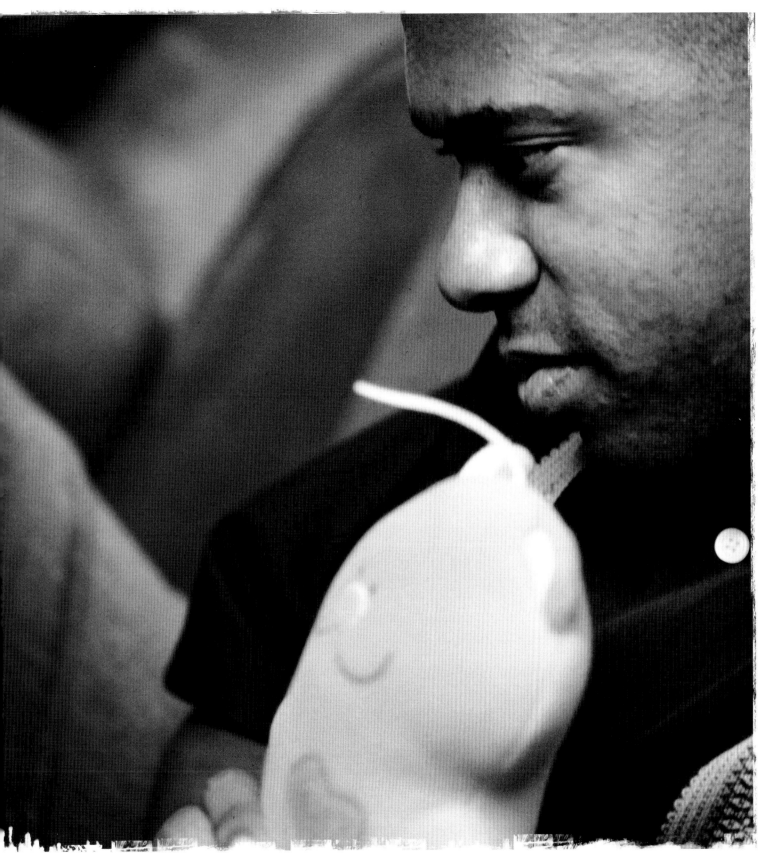

GREG

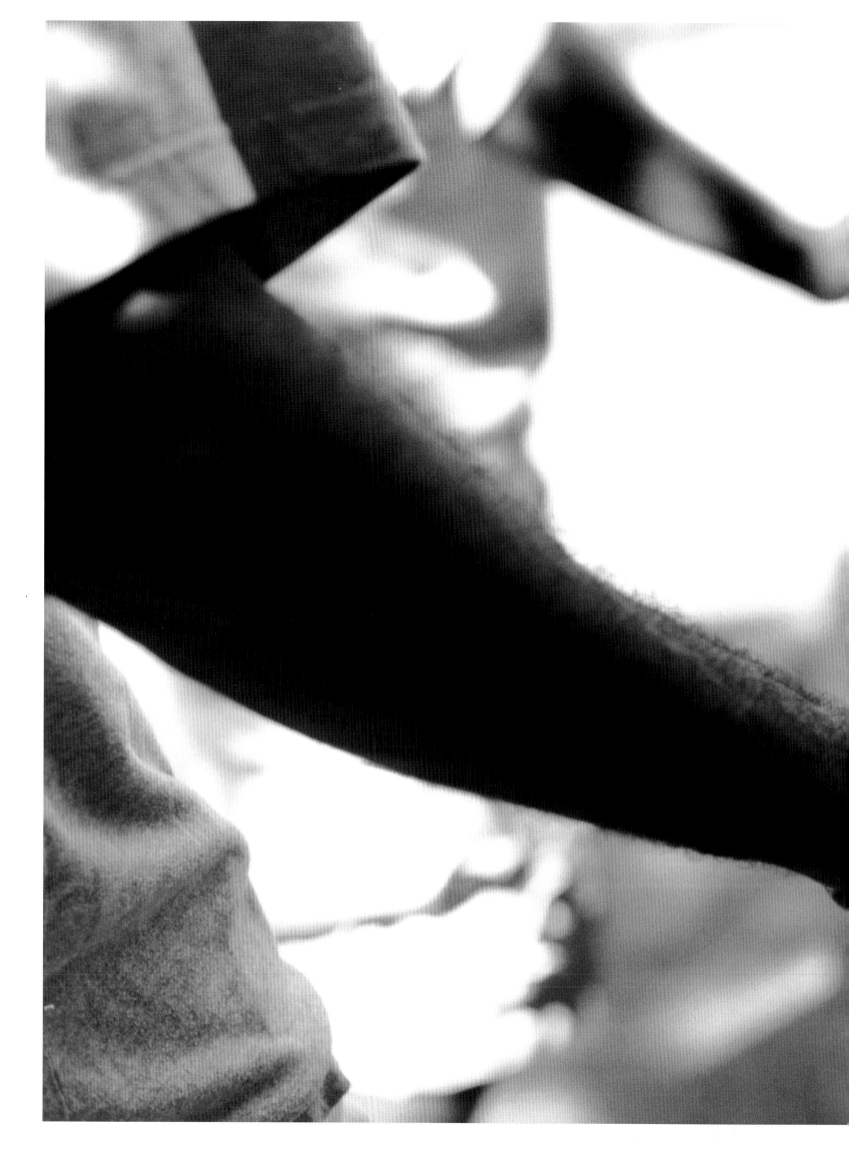

Guess how many times a day children laugh out loud?

Answer: 300 to 500 times a day.

How many times a day do adults laugh out loud?

Answer: 7 to 15 times a day.

Guess how lucky I am?

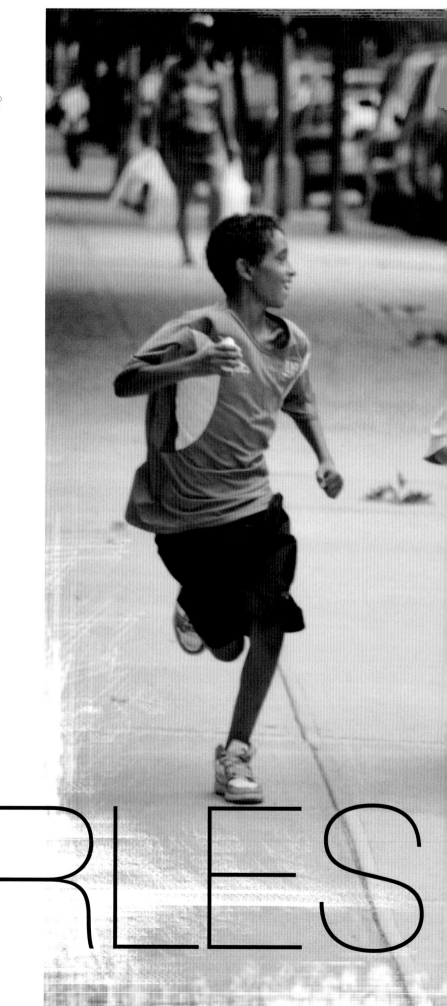

CHARLES

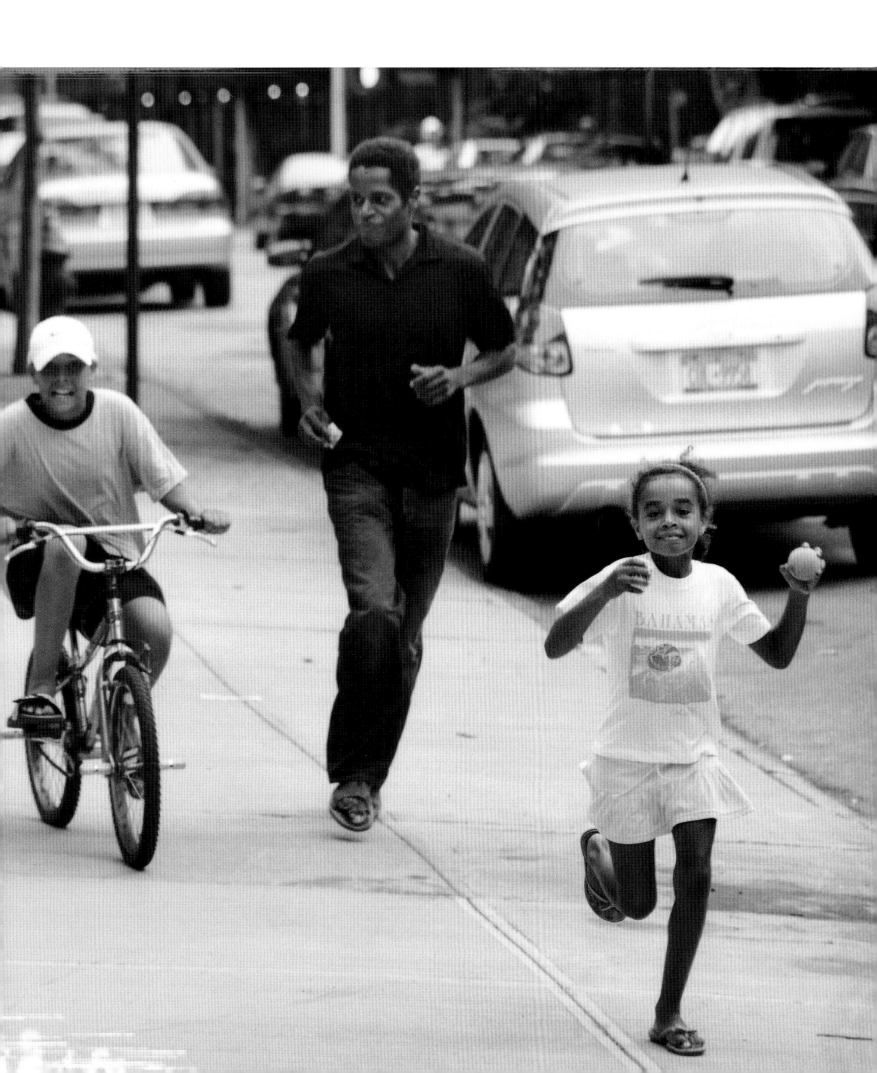

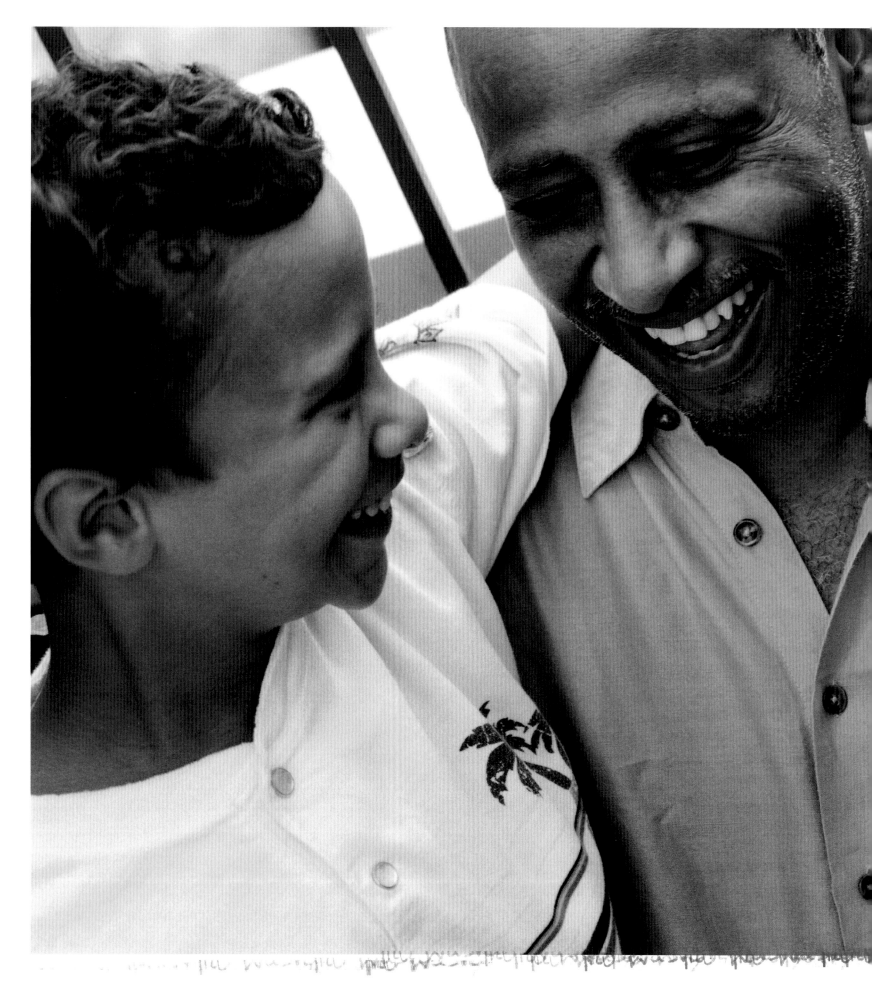

Being a father is the most direct and sincere challenge that a man can have. That challenge is one of responsibility. Fatherhood challenges you to be caring, loving, nurturing, considerate, thoughtful and responsible. When I look in my children's eyes, that challenge becomes a blessing. I was asked how I would like to be remembered and without thought my immediate response was, "a fair man and a good father."

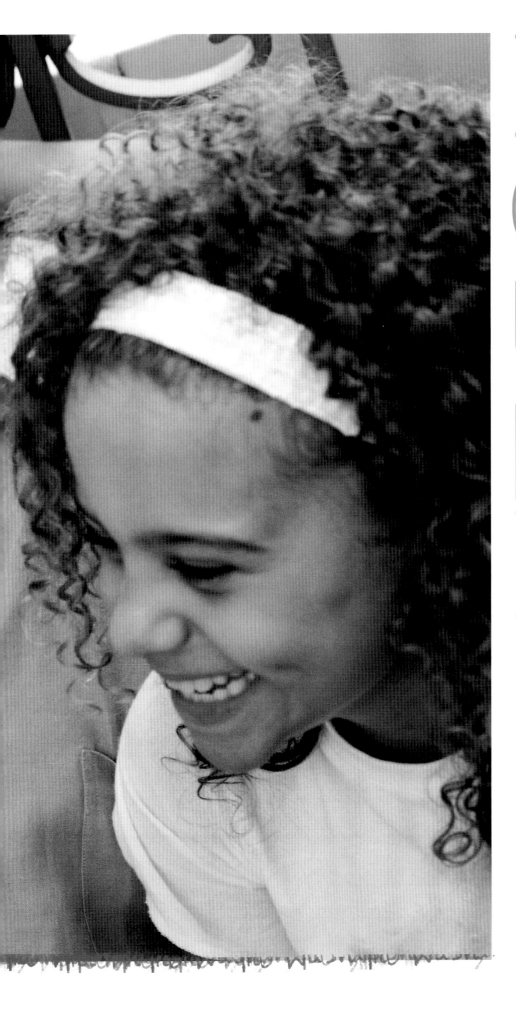

RUBEN

Being a pop is my greatest achievement. I am very proud of both my children. On my worse days, any thought of either makes me smile.

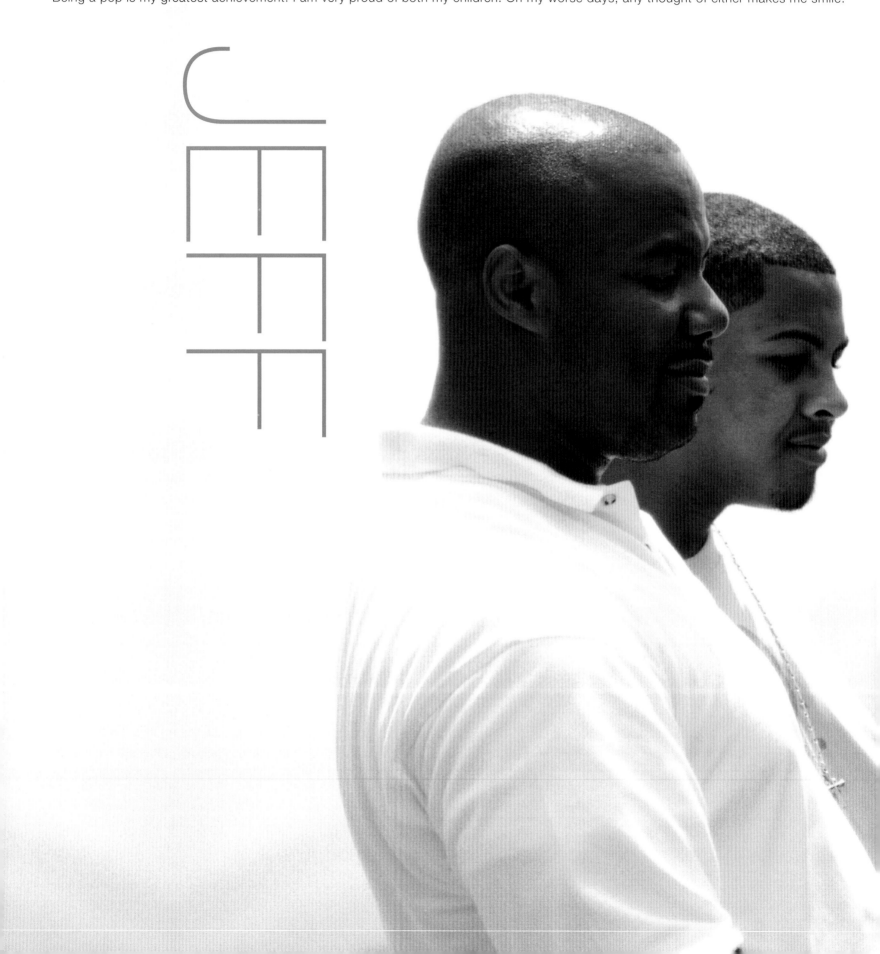

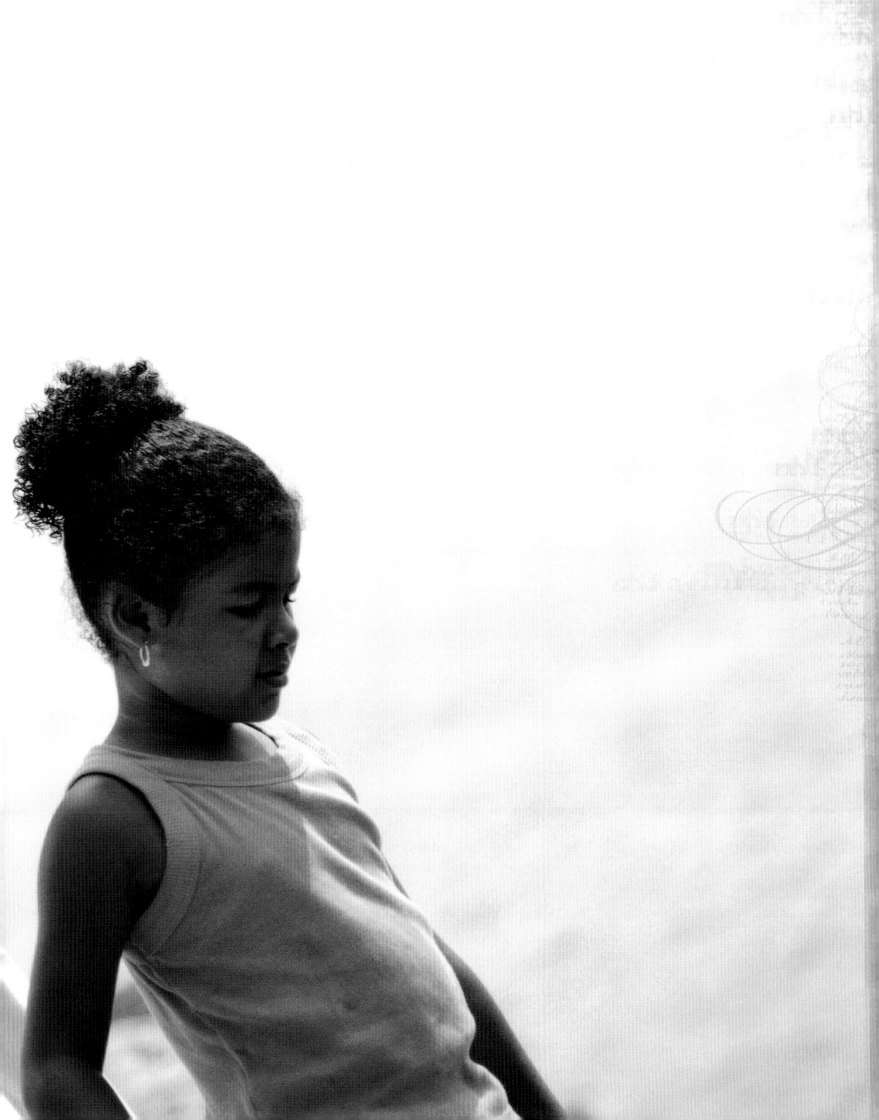

JAMES

Fatherhood means silly love, playful love, tough love and unconditional love.

Almost daily, I run a mental checklist as to how my personal day has developed, not only as a man, but also as a father. It's not a list worthy of the headlines of USA Today or the evening news; it's my own personal list. No handbook, no "how to" guide, not even advice from other brothers can create a regimented formula of what it takes to be a successful father. I know I won't be graded by a former college professor, sneak a peak over my shoulder at a former priest for approval or even be judged by fathers who've come before me. This list is mine and mine alone. Did I listen? Was my advice ill advised? Do they feel safe? Did my message get through? Do they know I love them? Is there milk for cereal in the morning? (O.K., maybe my wife asks that one more than I do.)

Growing up a young black boy, I bore witness to countless discussions about my impending manhood. When will it come? How will I know? Will I be a better father than my father? The answers? There are none. Not in the literal sense. But for me, there is one constant that rings true—love. Just love. This love drives me to be the best man and father—mistakes, warts and all. In both cases, the goal is to be the best. I did not understand what it really meant to be a father until I witnessed the birth of my daughter. That was the start for me. This is what I'm here for. Her every hope, dream and chance for a life of love and promise is in our hands—her mother's and mine. Ambitious on my part, yes, but at that moment I knew deep in my soul that the responsibility to offer her the best of everything within reach was the very least I could do and I would not fail. Because to fail would in turn negate my purpose here on earth.

I believe you must talk as well as listen to your children. I believe in allowing them the opportunity to express themselves and ultimately through that process we work things out. They will need the benefit of self-expression in order to move with ease through society without feeling compromised, intimidated or incapable of communicating. It's my hope that their lives now are practice for the future, a dress rehearsal if you will, so that they're equipped to deal when it counts. My children have something I didn't have as a child and that's the security in knowing that they can absolutely talk to me about anything. During our dialogue sessions, they get the benefit of my experience (albeit sometimes unknowingly) and I surprisingly get from them insight beyond their years.

We are living in a global society where things are moving fast. Helping to prepare them for the narrowing gaps in our multi-cultural world is without a doubt a huge priority. That being said, I will always make personal time for my children. It's important to me and non-negotiable. Above all else, my children must feel secure in that whenever possible; my time is their time. Time for love, laughter—absolutely laughter—and time to create memories. Time always moves—we can't get it back. Ever. I one day will hopefully be old and gray and take pleasure in witnessing my children's entry into adulthood. Maybe I'll see just a little of me in them. So when they are asked, "What did your father give you?" behind a smile, the response will simply be … LOVE.

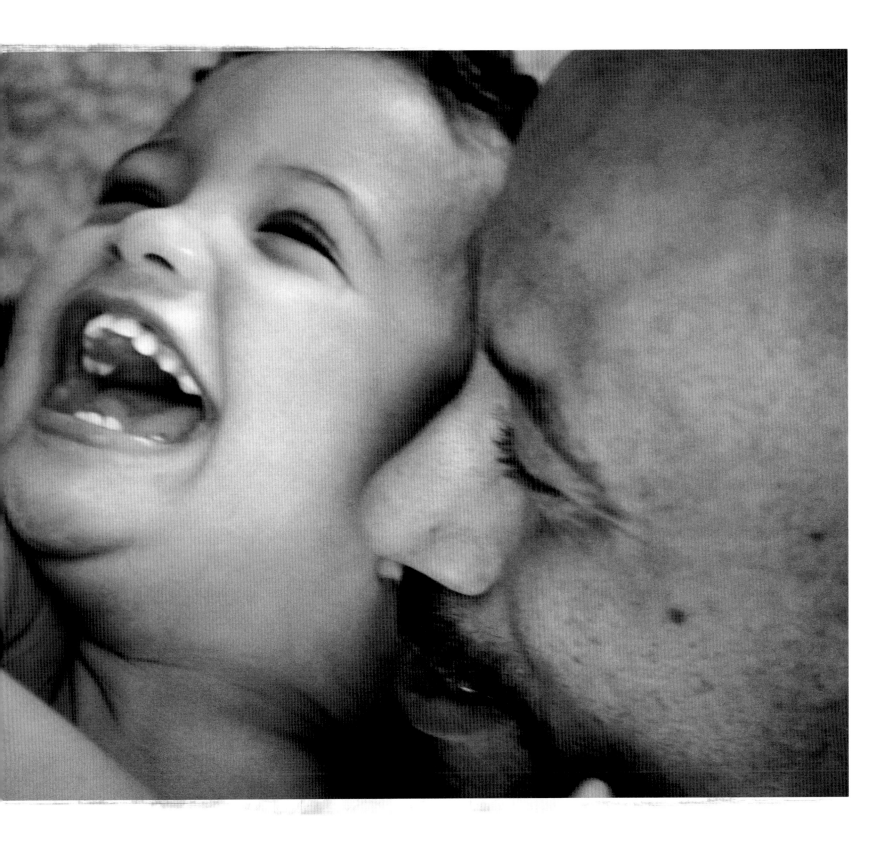

CHUCK

Fatherhood is the purest, most gratifying opportunity to pay homage to two of God's greatest gifts, the miracle of birth and the ability to love. It is part of my destiny, my privilege and honor to be the greatest father I can be to my daughter, Sydney. I know love intimately as a son and as a father. I am blessed.

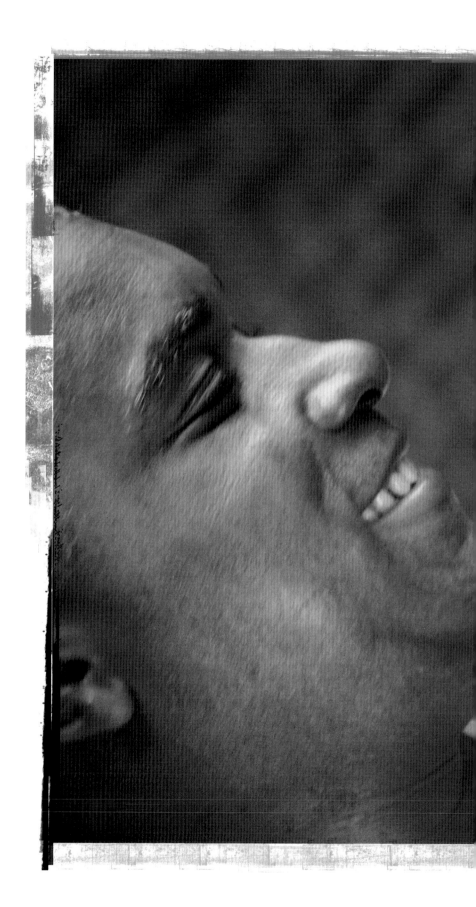

MICHAEL

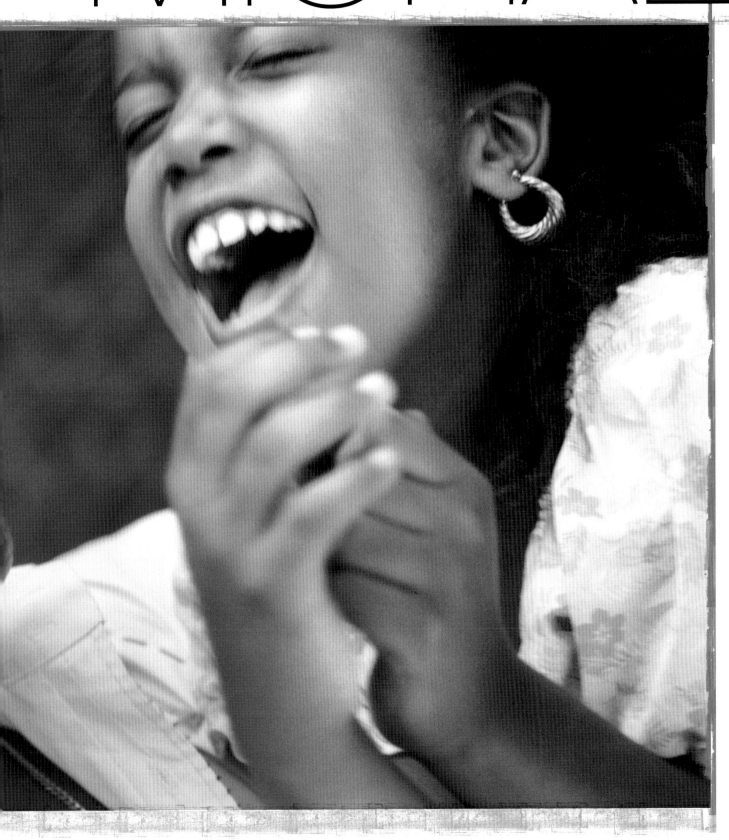

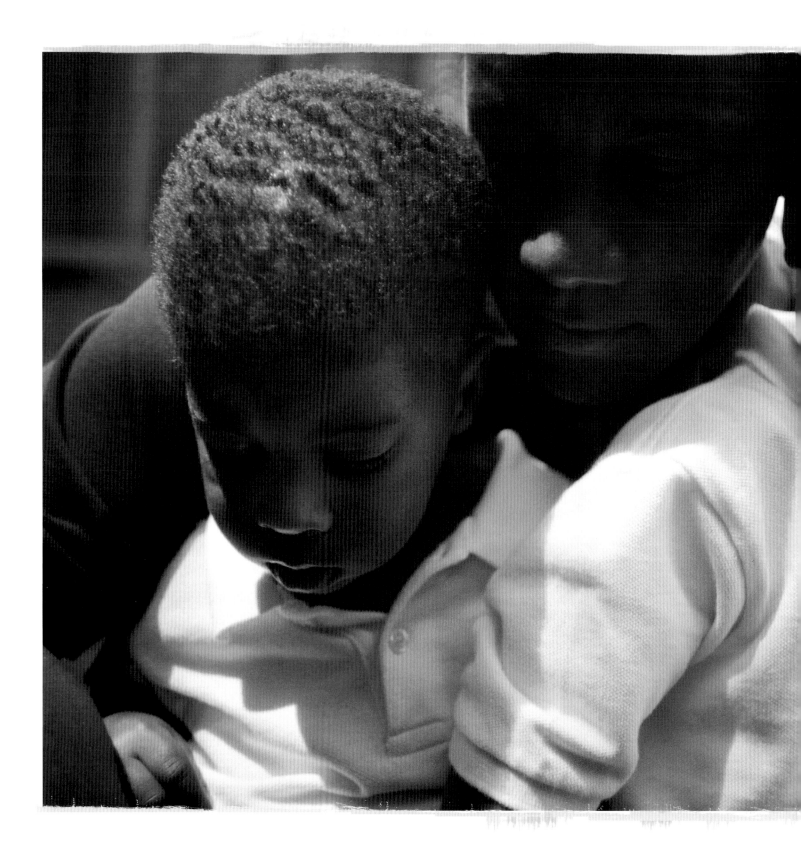

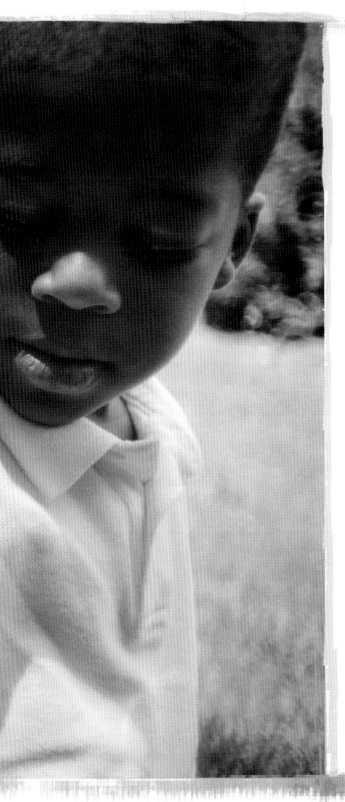

A pop is a teacher

A pop is sensitive

A pop is loving

A pop shows you the steps

A pop corrects you

A pop gives you direction

I am blessed to be a pop

I was never blessed with a pop

JEFF

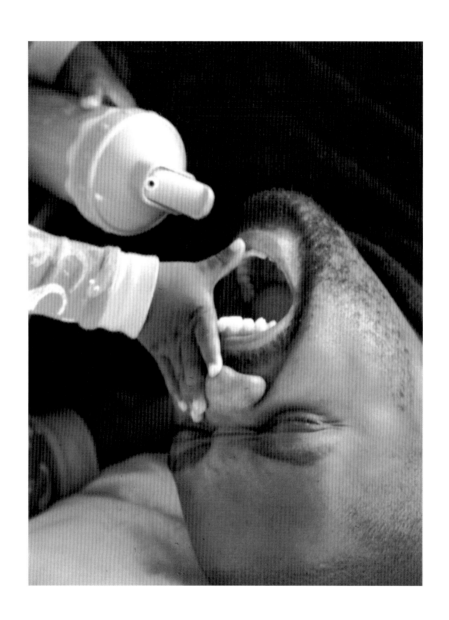

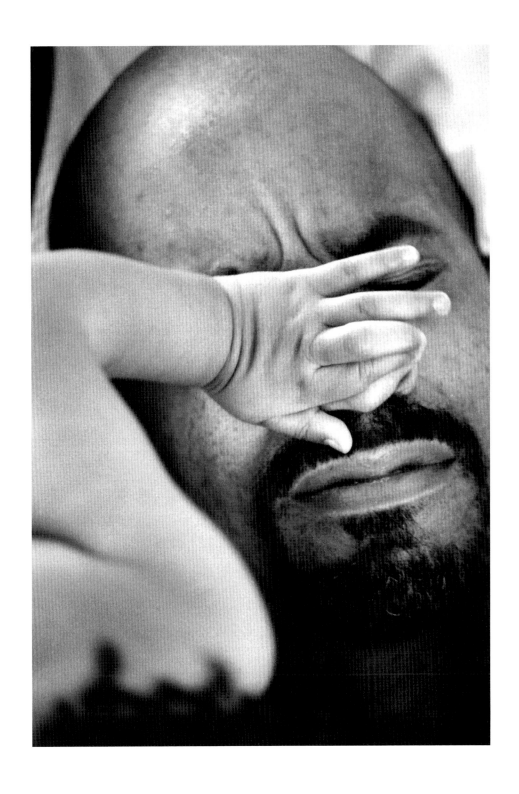

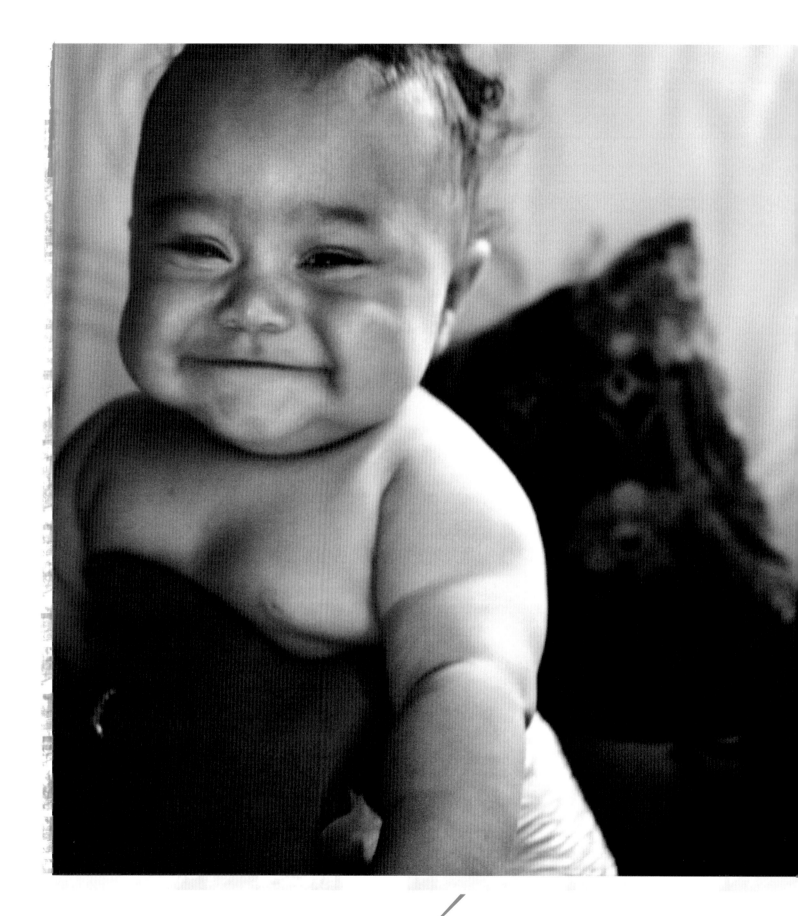

RENÉ

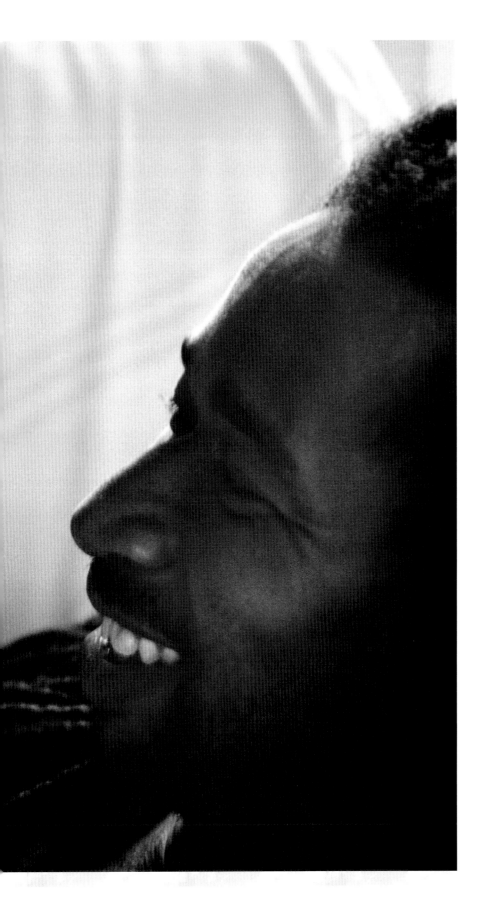

Being a parent is the finest expression on the path of being a human being. I look at my son and I say, what an opportunity to make the world a better place by cultivating positive traits, even traits lacking in myself. Love and devotion are the highest vows of parenthood. The key to understanding the nature of my child is to remember my own childhood. I always seek to cultivate enduring traits in myself before I pass them to my son. I ask myself what I want my child to learn. If I haven't developed the desired trait, I then go through the process of self-cultivation. A child only imitates. I must BE the things I want my son to learn.

My first rule in raising children is to understand why they came to this world and how I am going to assist their development. My second rule is to watch and look for any natural gifts they might have brought into this life. My third is to use their natural gifts as a way to set up a foundation for learning about life! For instance, if my son had a musical ability, I would help him cultivate that until he was proficient. I would use the philosophy of music to help him understand the rhythms of life, business, education and mathematics. It's really just maximizing the learning style of the child.

I culturally seek to instill ancestral heritage from both races but most importantly help him recognize himself as a spiritual being. I find that I learn about myself by watching him. Being a black father means that 150,000 years of wisdom is encoded in my DNA. My job is to bring that out in myself and my child. I always give reverence to my elders ... even the younger ones!

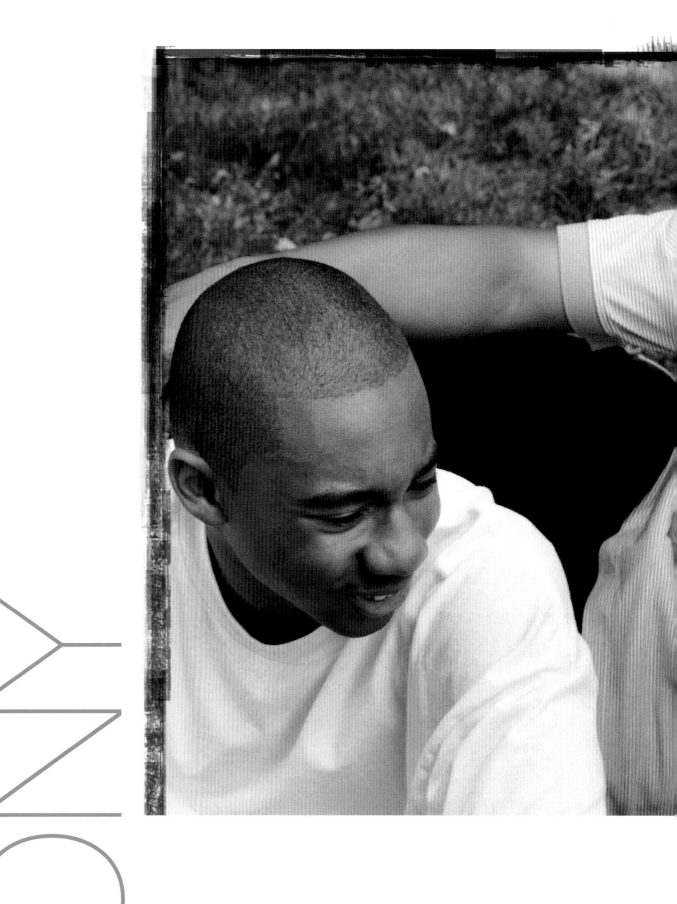

TONY

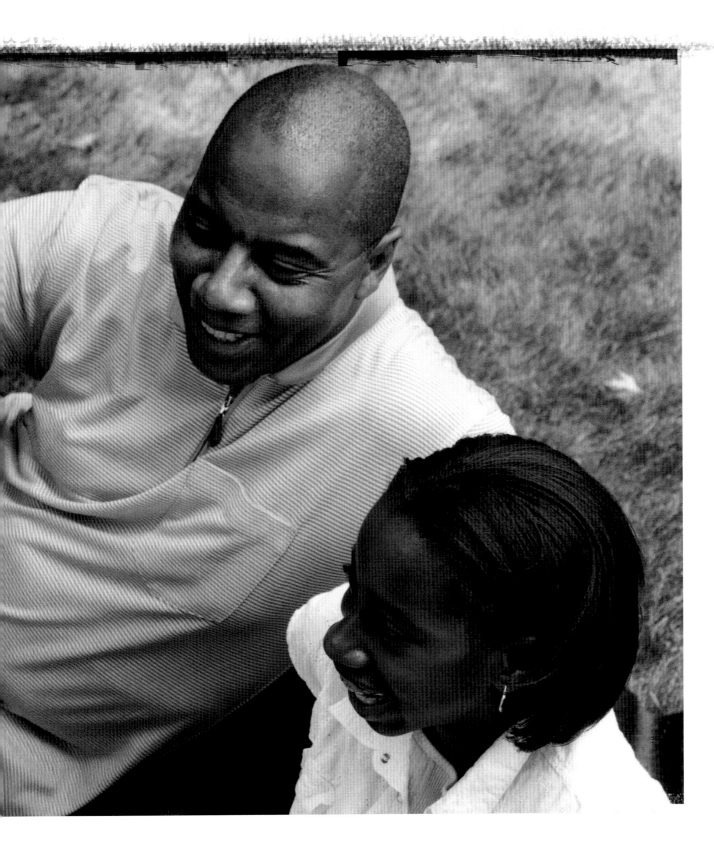

Being a father is joyous, tedious and exhilarating all in one breath. Being a black father is a mandate and requires the ongoing

rejuvenation of God as your inspiration to carry on "in spite of." In spite of the cost, in spite of the fear, in spite of the lack of support

and in spite of the lack of appreciation for the fact that you are climbing Mt. Everest with no gear. I proudly love my children and I

dream a dream unimaginable for them. I have given my life that they may have a chance at true freedom of speech, action, wealth

and power. I prepare for my grave knowing I gave them every ounce of my love and fought on their behalf. I closed the gap, I shut

the door, and I am the gangplank for them to walk into the future.

As someone who works in a creative field, having made three films and written several screenplays, my boys are the greatest accomplishment I've ever had a part in creating, by far. I had a great example of a supportive, nurturing, positive father, Cliff Lee, who encouraged my dreams yet kept me grounded. I felt like I could do the same with children of my own with the right mate.

Parenting is hard work! It's no longer about you and your wife. My boys can drive me up the wall at times, but moments later they warm my heart, inspire me, and astonish me with how they develop. Learning how to be more patient is hard but deeply rewarding. I can totally see the day when I will live life again through my children. It is rewarding to see them progress, accomplish goals and overcome their fears. It makes me smile and shed warm tears of pride each time they get better at things and discover new things that interest them.

The most challenging part of being a father is having patience and being flexible enough to accommodate them. Fortunately, I have a schedule that is at times flexible. Black fathers are perceived as nonexistent, so I feel a great responsibility to be a positive role model and influence on everyone, especially my own children. My parenting style is a mixture of tough love and encouragement, with a healthy dose of discipline. Black boys need that. It's also great for the child to see the father doing "domestic work"—cooking, cleaning. They have several obstacles to face in this world and I want them to be prepared, but at the same time I want to instill in them a belief that they can accomplish anything.

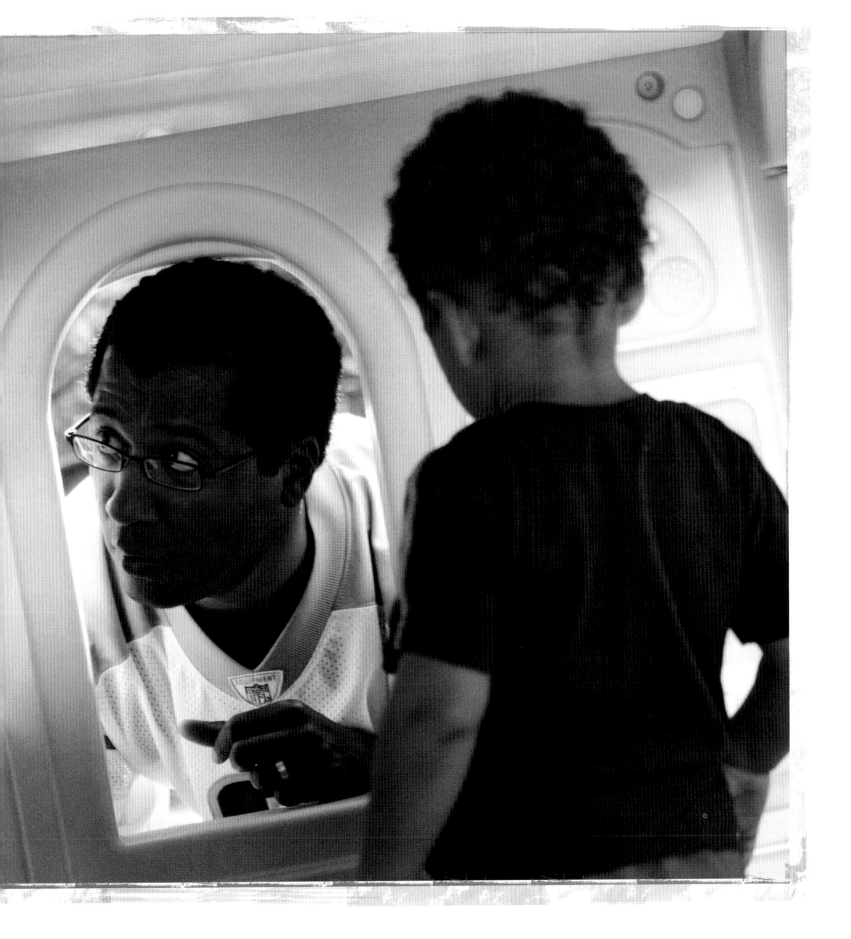

MALCOLM

DOMINIC

For me, being a father means trying to make right, where I felt my father, as much as he tried, went wrong. I came from a dysfunctional family, where witnessing spousal abuse and having to step in left an indelible mark on me and my relationship with my parents. I struggled with this throughout my life, but when I held my two sons in my arms for the first time, I felt that NOW everything was right in the world. I would aspire to be a father with the joy and absolution that fatherhood brought me when I held my two boys at birth, no matter what life challenges came to the fore.

As much as I drew strength from the birth of my children, I also felt that that love must have come from somewhere. That somewhere, in the deep recesses of my emotional mind, I was loved unconditionally. I deemed that I would not wallow in the dysfunctional hurt, but rather concentrate on the good that my parents shared with me. My mother read to us as children. We three huddled around her, trying to get the best angle to see the words she was forming with her soothing reading voice. I have picked up the torch in this regard and we now read in subways, buses, libraries, parks, cars and anyplace else we might find ourselves waiting.

After all of the hurt my father caused, what joy could I possibly have garnered from him? Well, my father was probably the only father on our block that played with us. From my father, I gained two experiences. One was to laugh with my kids and the other was to play with them.

I aim to continue trying to incorporate the joy my parents created and shared with me and my siblings, whilst I traverse this learning journey of parenthood.

I didn't grow up with a father and I never really felt the absence of one until I became a father myself. I noticed how my presence was always so meaningful to my children and gave them that special something that would provide them the confidence they would need to accomplish anything they envisioned. I didn't have that in a father and now I realize how important a father's role is in raising children with a balanced life full of hope. Whether it be the most trying and difficult challenges, or the simplest little thing that matters to them, they know I'm there. I am so incredibly proud that my children are, above all else, really good people with kind and loving hearts. They are respectful, smart and beautiful.

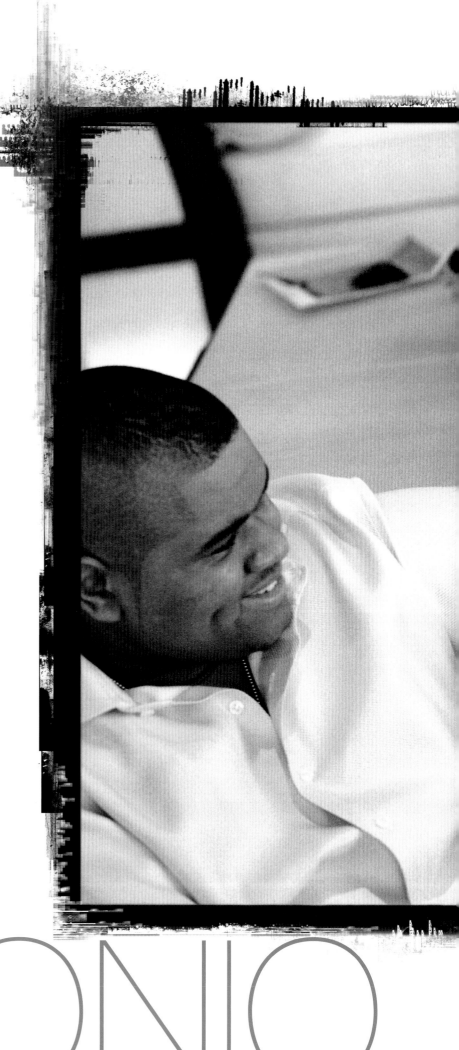

ANTONIO

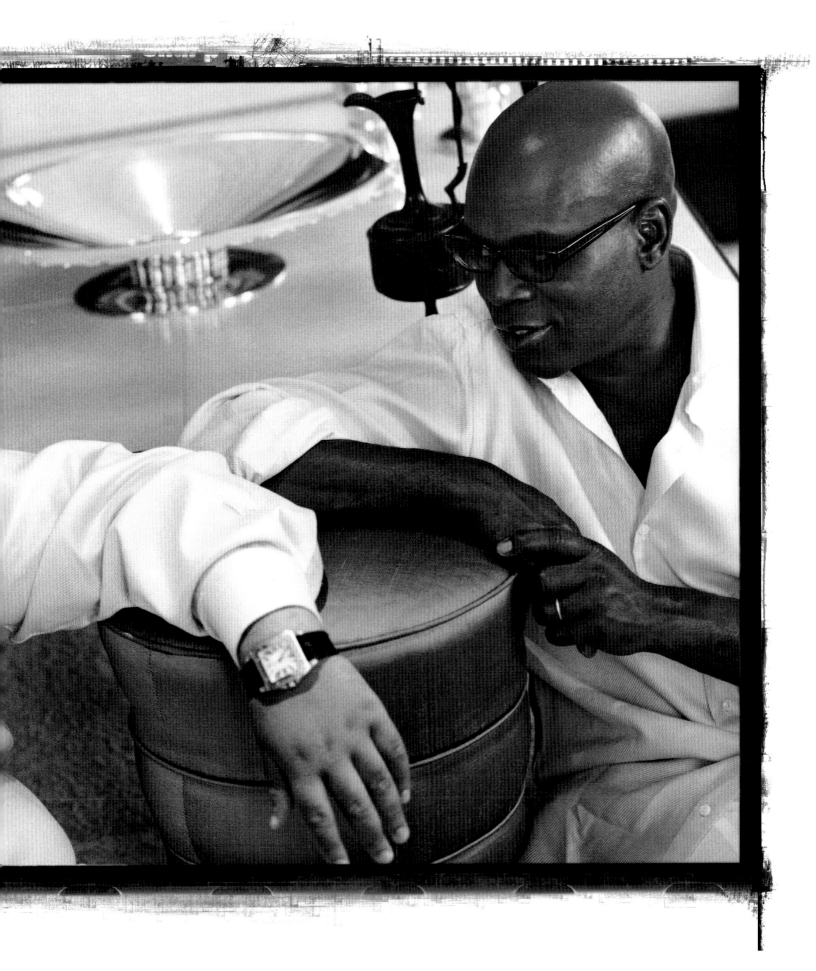

Being a father to two beautiful, inquisitive and creative girls has brought meaning and challenges to my life. Maiya and Kayla are my daughters and they mean the world to me. This part of my life has made me mature, wise and patient—qualities I lacked as a single, childless man. Parenthood has raised my consciousness. It's a huge responsibility to be a good parent. It takes maturity, patience, unconditional love, generosity, communal support, etc. to do a half-way decent job.

Fatherhood has been the most joyful, challenging and frightening experience I've ever gone through. As a father to girls, I teach them about the positive male role. What they learn from me about men is how they will relate to men when they grow up. Through me, they can learn that men can be sensitive, loving and good providers and respectful to women. I was raised with good morals and childhood experiences and I want my beautiful brown girls to have positive experiences growing up as I did.

I remember the evening when my youngest had a seizure and I ran down Dekalb Avenue with her in my arms. It was the most frightening, powerless moment in my life. As I ran, I felt her limp body and I thought I had lost her. But something told me to keep running and I made it to the hospital in time for her to be helped. My other daughter had asthma as a newborn. The first time I heard her having difficulty breathing, my heart sunk. Knowing that the baby you brought into this world is having trouble surviving, you want to do whatever you can to put her at ease. Fortunately, she got better and grew out of it. The ups and downs of fatherhood run the gamut. There are times of laughter and joy and times for crying and sadness. Even with all the things that I've experienced as a father—late-night feedings ... a colicky child crying all night ... her first crawl ... first word ... first steps without assistance ... potty training ... first day at daycare ... first tooth—just hearing your kids scream, "Daddy!" when you come home from work makes it all worth it to be a dad.

CHRIS

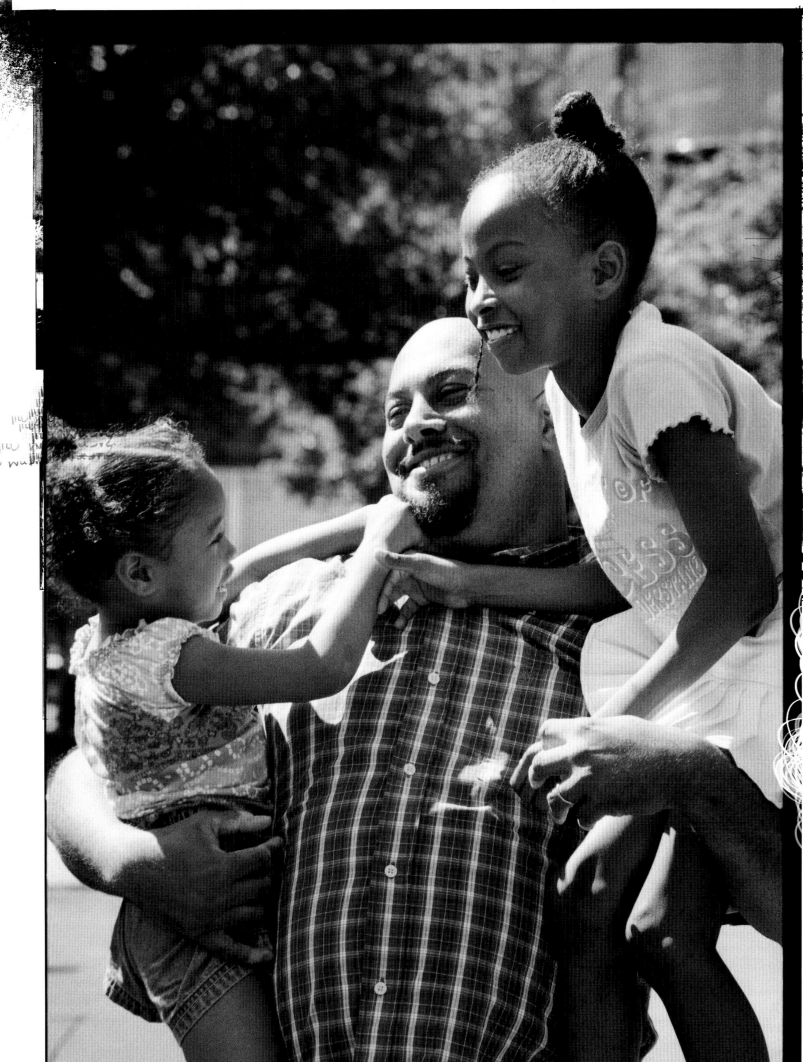

I never wanted to be a father. In fact, I thought I would be dead by the time I was twenty-five. My life wasn't particularly difficult or challenging, but somehow I got it into my head that I would die tragically young.

It would be so easy to be an average father. The expectations for a man to be a good father are really low and you're constantly reminded that you could do next to nothing and it would be acceptable (perhaps even preferred). I sometimes get the feeling that as a black man the expectations are even less than your average father.

I believe that the core of my job is to teach my girls how to make the best choices possible from the many options that will surround them. As the world gets more complex, the decisions that children are forced to make happen earlier in life. Teaching decision making and the consequences of decisions seems to be the core of my work. For me, the most meaningful insight has been that there is a critical difference between power, force and influence. It's sometimes hard for me to remember that as a six-foot-two-inch, 200-pound man, my power and ability to force my will on my children in no way influences their behavior. Especially when I have two feet of hair and attitude telling me what she won't do, why she won't do it and that she doesn't love me anyway! Its hard to admit that force doesn't equal power, and neither—no matter how judiciously applied—can equal the long-term impact of influence.

Being a father is hard. Nothing is harder since children come with no instructions or manual. Each one is different and needs different things, so few of the lessons from the past apply. You can never have enough patience, time, experience, support, resources, friends, knowledge or distance to do the job perfectly.

I don't think I'm as grown-up as my father was when he had me and my brothers. People seemed to age faster in his generation and I don't feel like I have the same issues. I know I'm a very different father than he was. But I still feel that being a father has made me much more of a man than I was before and reminds me what fun being a child should be.

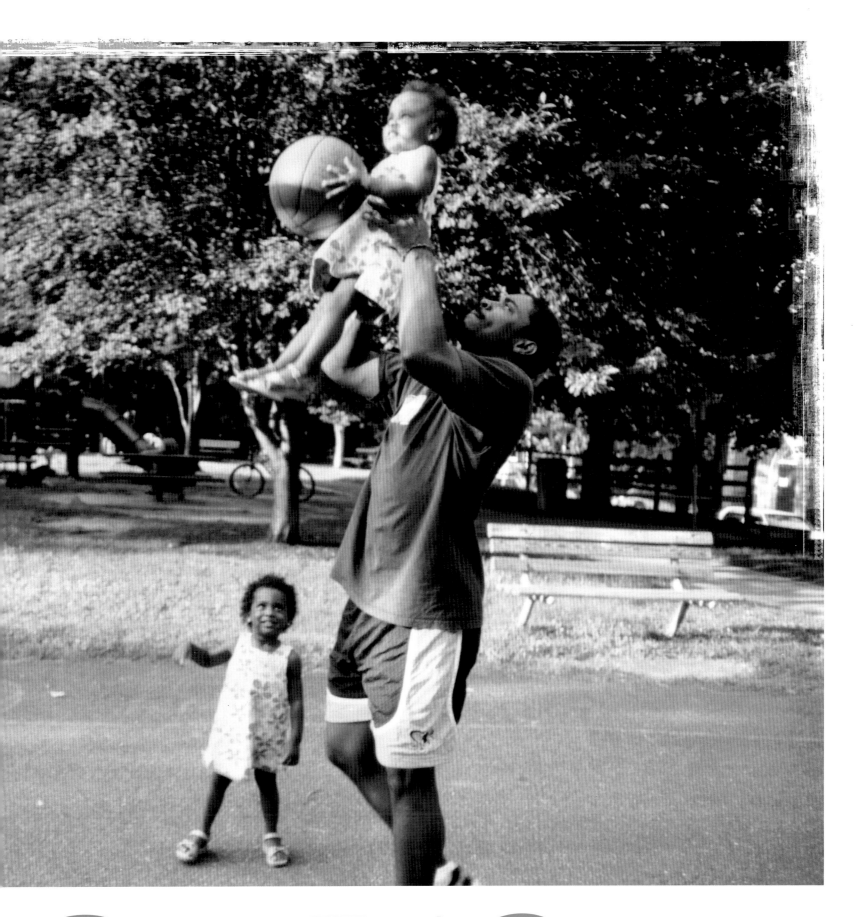

SIDDIQ

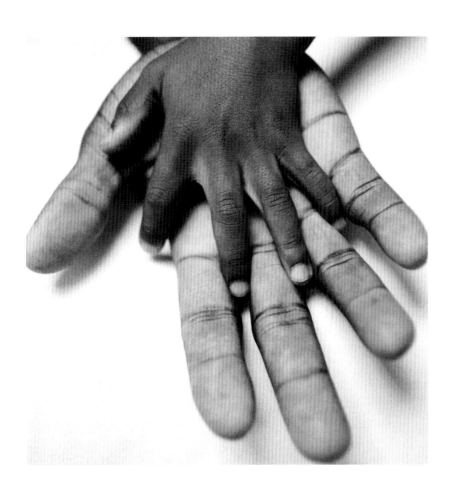

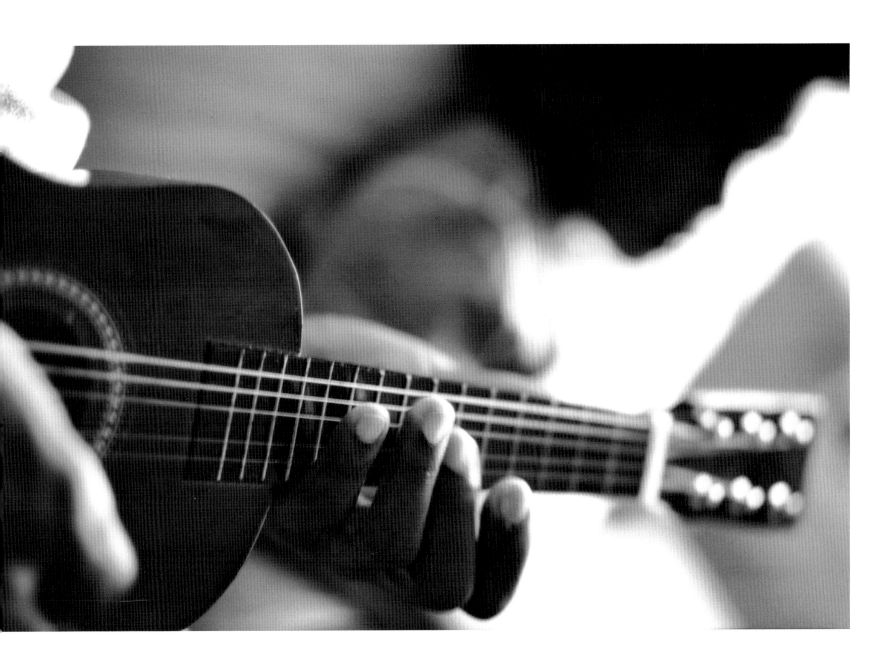

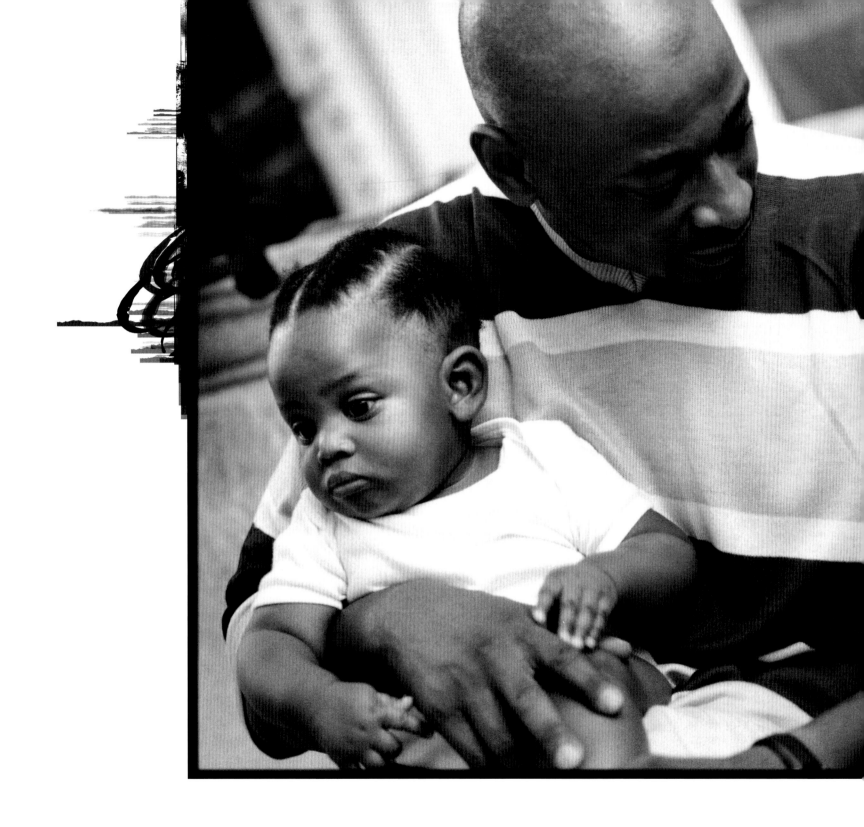

LORENZO

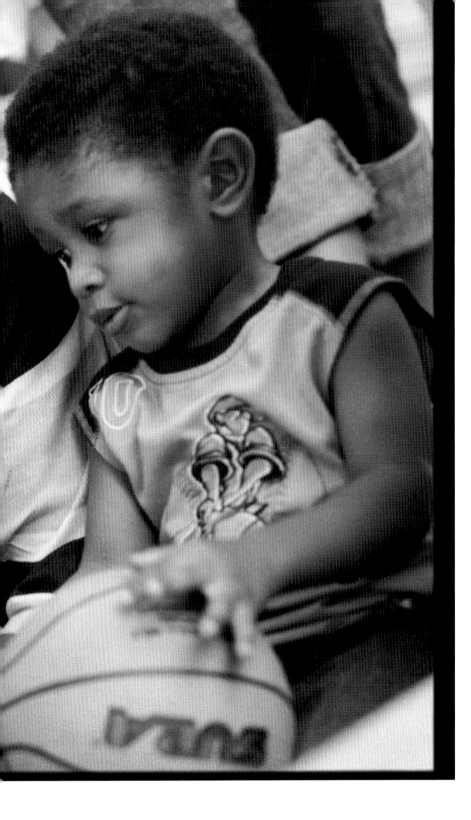

I first became a father when I was pretty young—twenty-two. To be honest, I was scared and overwhelmed. But when my daughter was born, I still felt like something amazing had happened. She was so fragile and beautiful and I couldn't believe that I had actually helped to bring her into the world.

Now I have four children—Naomi, Isaiah, Tuari and Kieran—and they have been the greatest rewards of my life. Life isn't always easy, maybe it never is, but they give me tremendous hope and my love for them is deeper than any love I've ever known. I try not to worry about their well-being, but as a father it's an obsession—you just want to protect them from everything.

With my two youngest boys, I've done the most growth as a dad. I think that has a lot to do with where I am in my own life now, and also the fact that so much of their immediate care is my responsibility. I fly home through rush-hour traffic every day just to pick them up from daycare on time. And when I walk through the door of their center, no matter what kind of day I've had, when my two-year-old jumps into my arms and the baby flashes his cute little smile, I know in my heart it's all good. Fatherhood comes with a lot of pressure, no question, but it makes you a much better, much more gentle man.

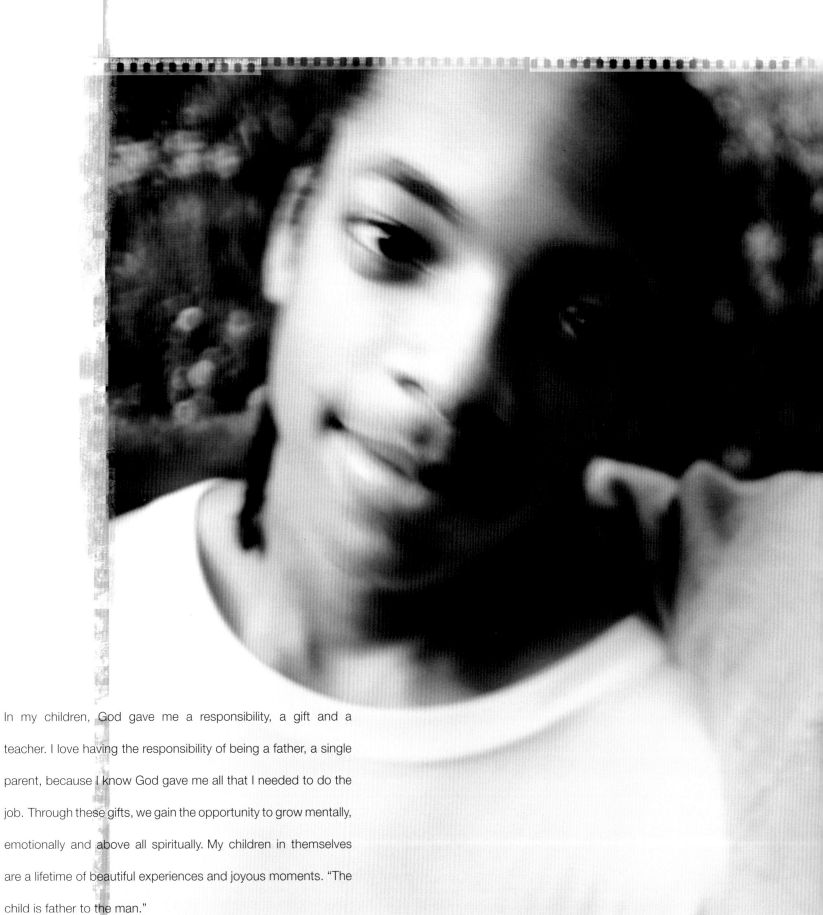

In my children, God gave me a responsibility, a gift and a teacher. I love having the responsibility of being a father, a single parent, because I know God gave me all that I needed to do the job. Through these gifts, we gain the opportunity to grow mentally, emotionally and above all spiritually. My children in themselves are a lifetime of beautiful experiences and joyous moments. "The child is father to the man."

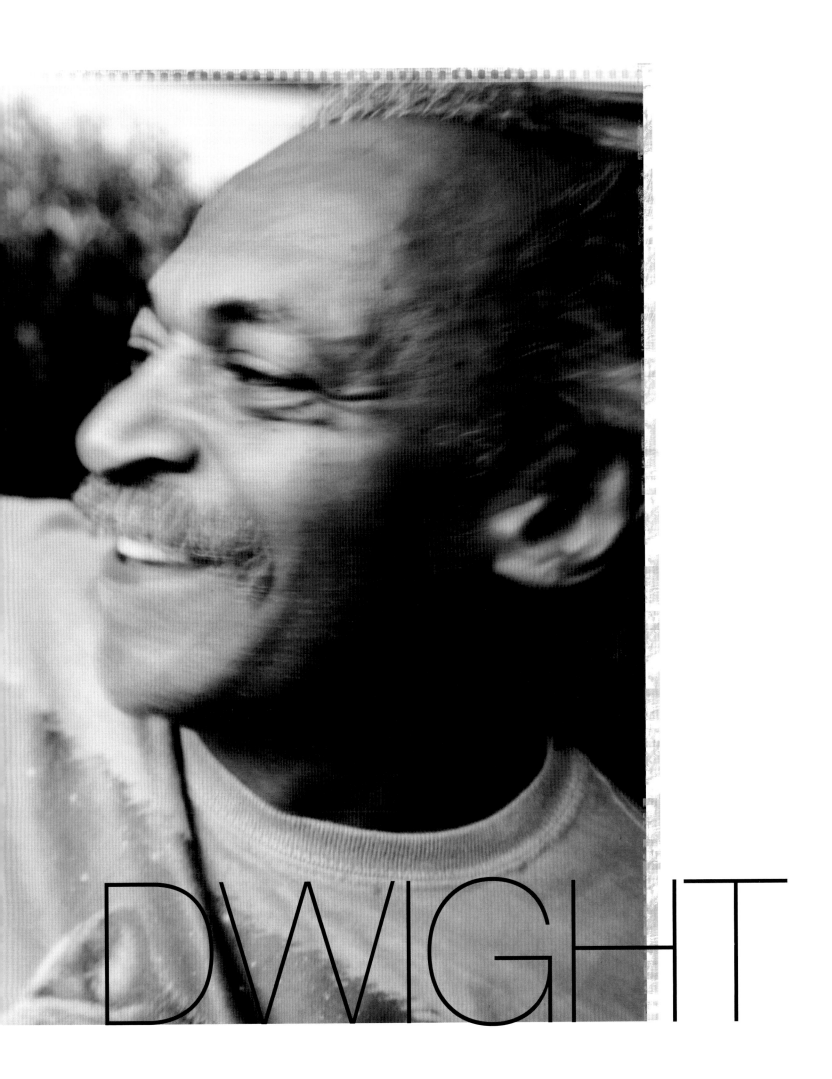

DWIGHT

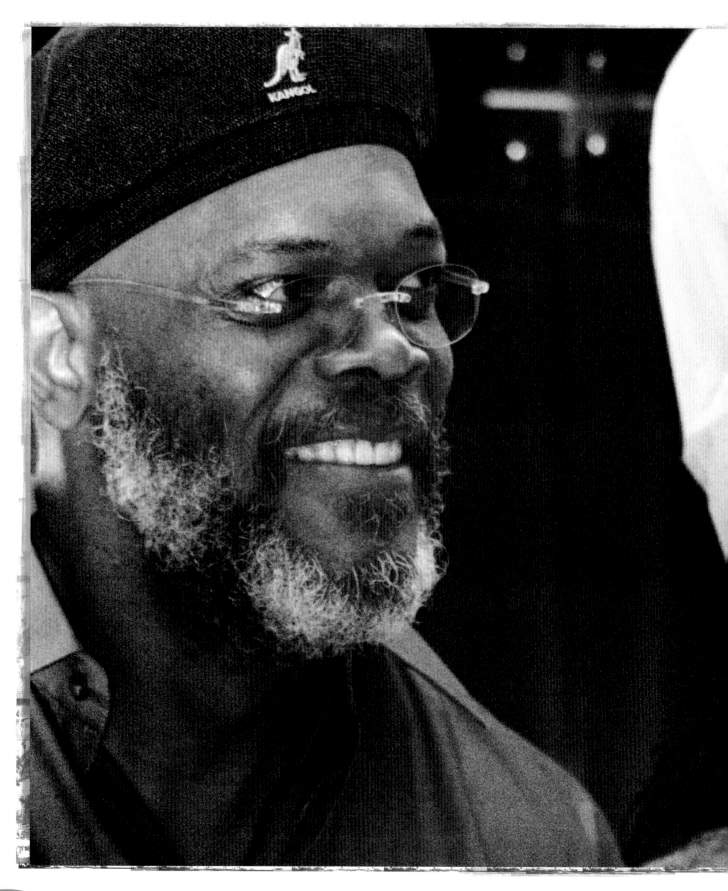

SAMUEL

I think of Zoe as an extension of myself, more than anything else. I look at her and I see me. People look at us and they say, "Oh, they're connected." Always. She has the security of family connections—a sense of where she came from, who she is and how she got here. In talking about our own families, my wife and I say, "These are the people who took care of us when we were kids and they care about you because you're connected to us. Bonding and connecting with them will give you stability when we're not here." A lot of people tend to neglect these connections and don't remember that there's a sense of warmth in a big family community. When your family sees you, they feed you. That's what they do. They cook. They send cakes. They send preserves. They still make greens with pork in them, and big ole rolls with sausages. These are her people, and that's part of what I have to give her— a sense of family.

Fatherhood is the ultimate test of the true measure of a man, and the gauge to measure the strength of a father's unconditional love. Even though my mother and father went their separate ways when I was very young, my father was still a powerful force in my life. As strange as it may sound, it was him that taught me to be humble, kind, caring and loving. Now, of course my mother was a special lady and she taught me a lot. She couldn't teach me how to be a good man — that I had to learn from pops. Even though my father was good, he could've been better, so I try to be the father I wish my father had been, while still hoping that I am half as good as my pops. I also have to give my grandfathers a lot of credit too, because they were also positive forces in my life. Every day I thank The Most High for bestowing such a blessing on me. And last but not least, I thank my wife Sharon, for giving me four beautiful human beings that happen to be my sons and for making sure I stepped up to the plate. She's made me a better person, a better human being and most of all a better father.

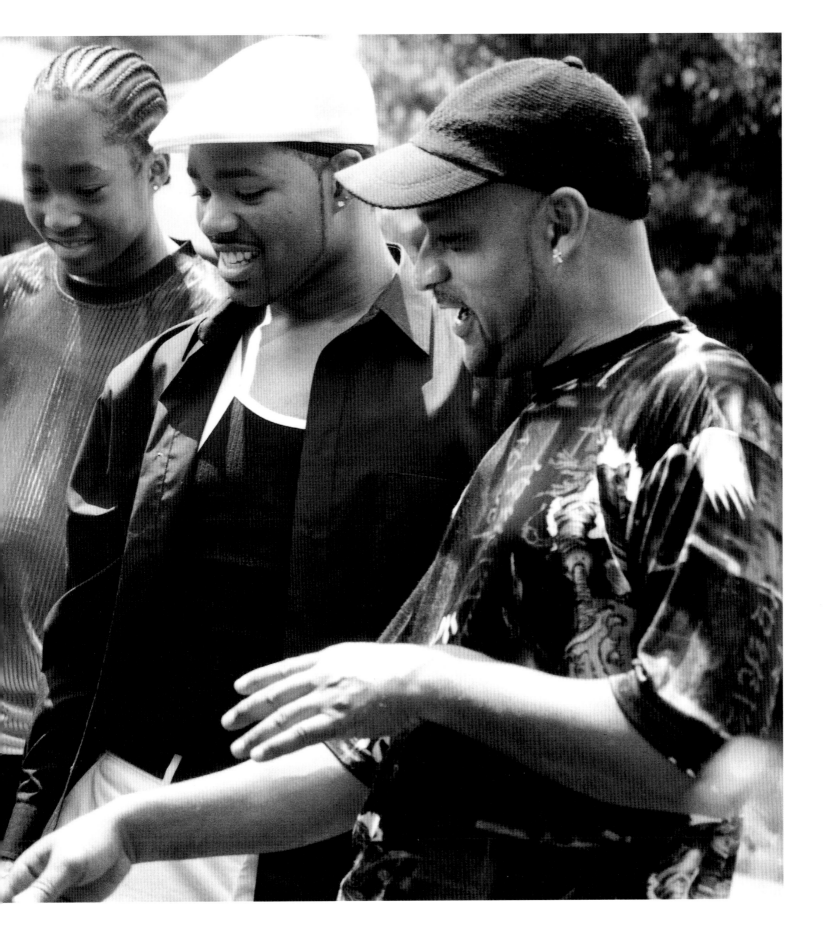

DANNY

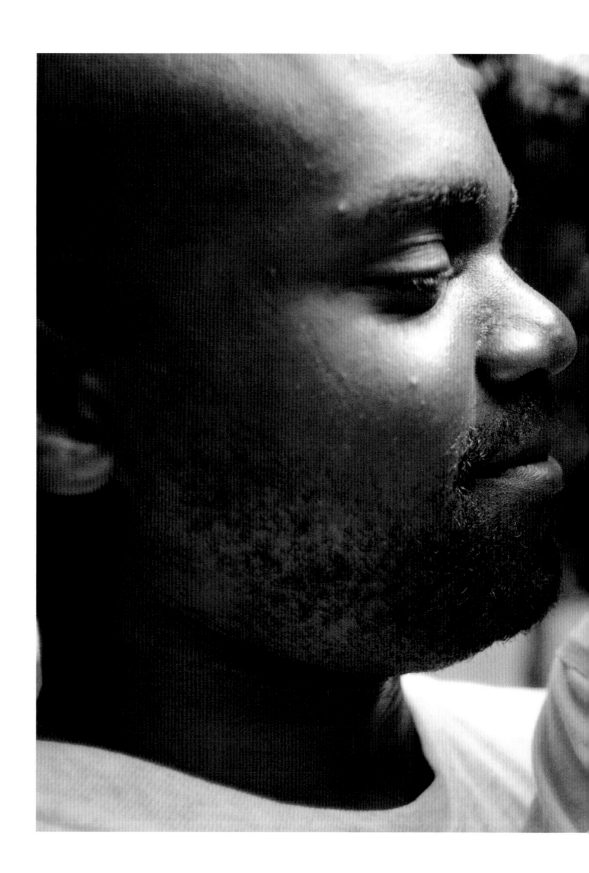

NOEL

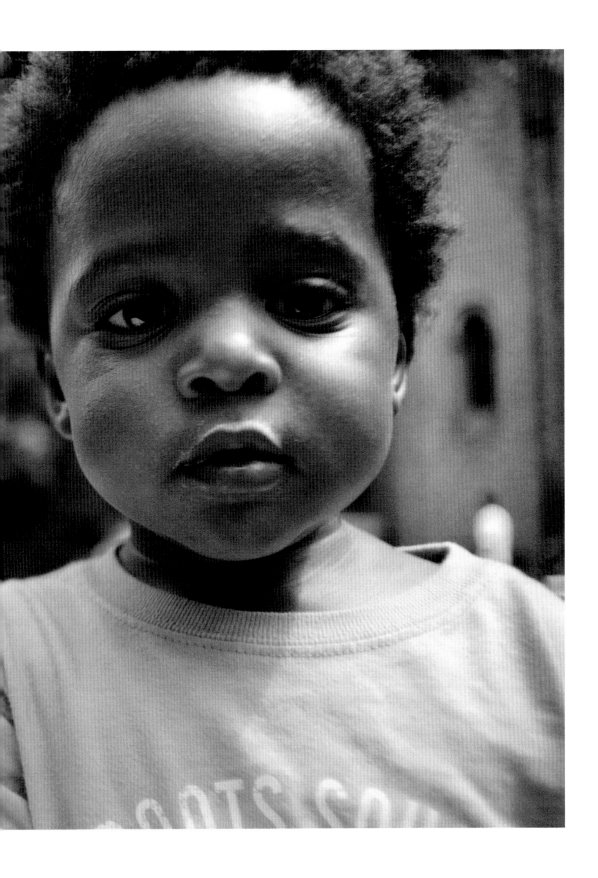

As black men, we are often conditioned by the negative images of us, about what we lack, about what we fail to do, about how we are missing

from our family as fathers. Yet the image of fatherhood, even in white society, is simplified to one of financial provider, which can still make you

feel inadequate sometimes. What I am learning more and more is that *providing* may not be providing much—that my attentive presence, my

hugs and my time are all my child really wants from me, and that makes me feel free.

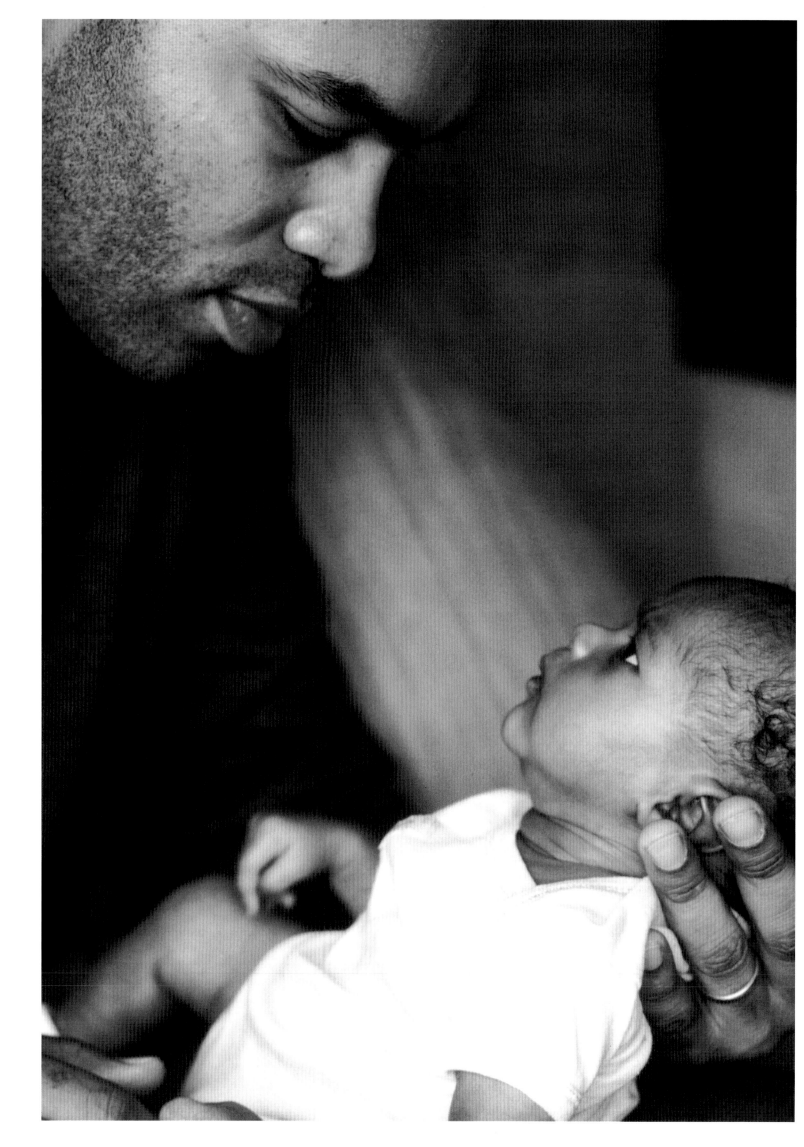

It is an amazing feeling to hold her.

There was a time when I walked around with her sonogram picture in my wallet.

Now I walk around with her in my arms.

She has become my greatest motivation.

She is why I sleep less, but have more energy.

I understand what it would mean to give my life for hers.

I am her protector for life.

When she was born, I yelled out to my wife, in the delivery room, "We did it!"

She is the ultimate prize.

JASON

I grew up on the south side of Chicago. In our neighborhood, two-parent households were the norm, not the exception. I always looked up to my father as someone who could handle adversity and primarily provide for his family through hard work. At times, my father worked so often that I didn't think we would be close, as work took him away from many of my activities. However, time and maturity, as well as adversity, have led us to form a strong bond.

As I am now a father myself, I want to improve the relationship between myself and my children as opposed to my own relationship with my own father growing up. I am happily active with my children through birthday parties, events, etc. My wife is an entrepreneur, which compels her to work on the weekends, leaving me with the challenge of caring for two young children alone, but I am able to store enough energy to provide them with a variety of new experiences during these times. As much as I don't get a break, those weekends are extremely special to me, and if in fact my business takes me away on a weekend, I spend most of my time missing them. I think it is important for my children to see that their father can take care of them, have fun with them, support them and handle all their needs, as demanding as they are (smile). They constantly make me laugh ... and I am a better person for this.

Ironically, I now face the same challenges/dilemmas that my father faced—how to balance work priorities with the priorities of my children. I often hear my father's voice when I talk to my children and I am comfortable with that because it shows that I respect his teachings and that I believe in them. I want my children to honor and respect what I have given them, the tangible and the intangible. This is what they will give back to their children when they are mothers and fathers.

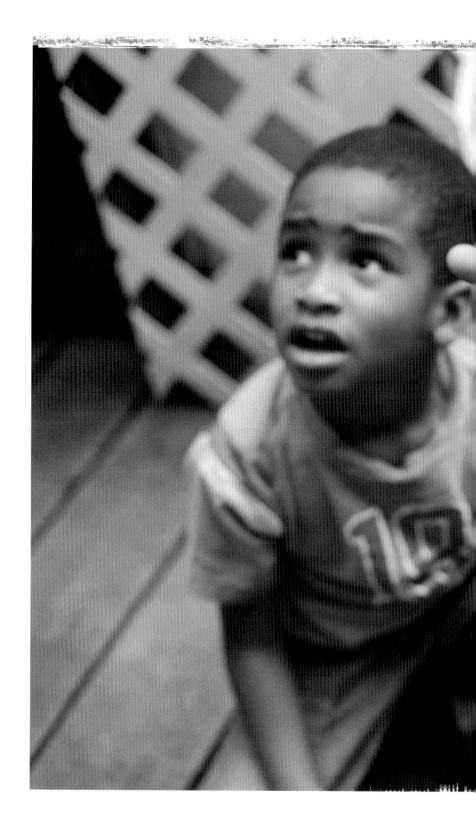

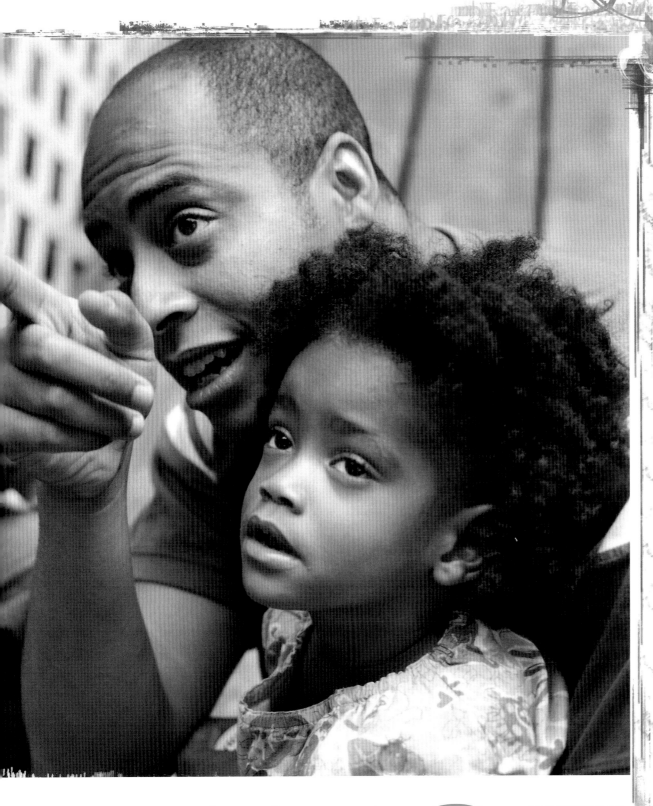

BRUCE

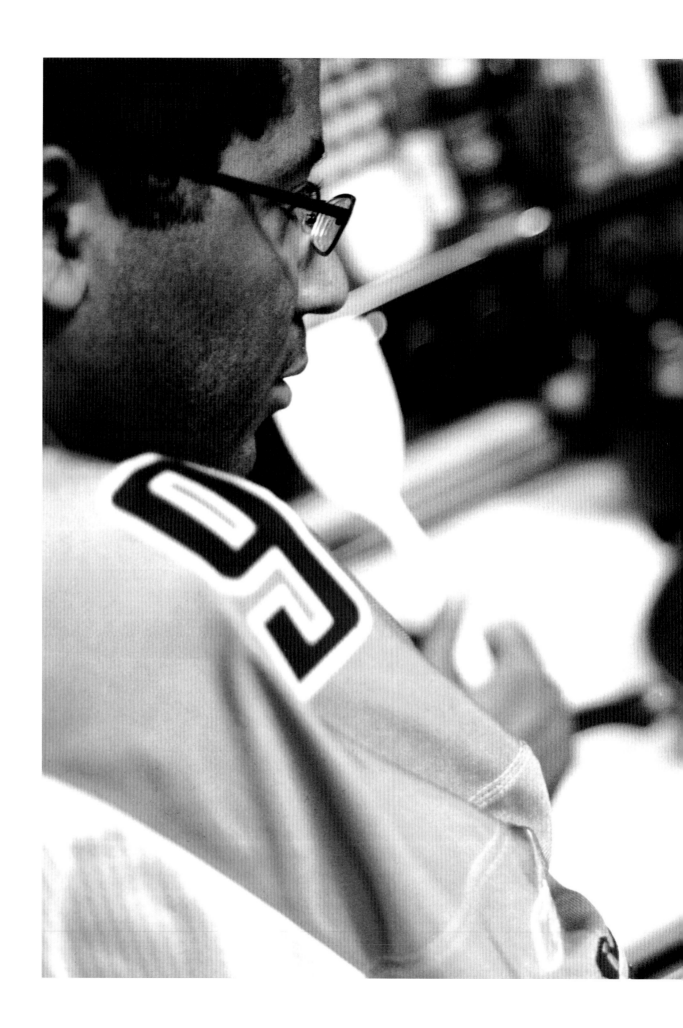

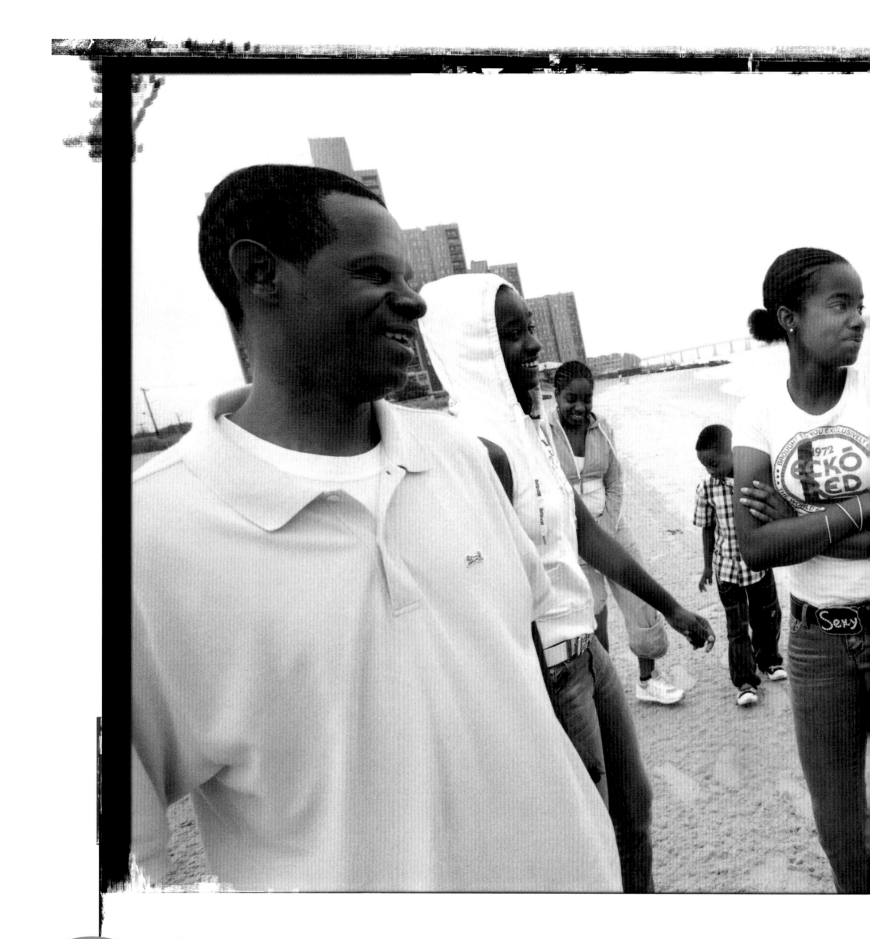

STEPHEN

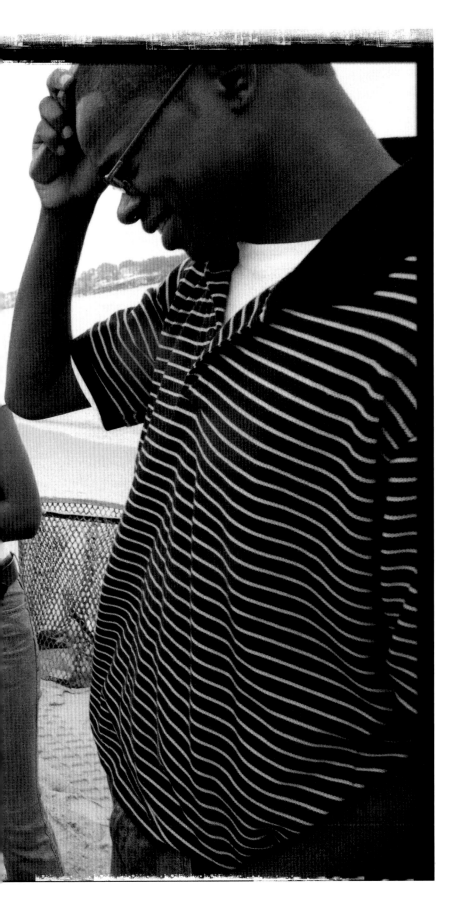

Fatherhood for me represents love, respect, and a lot of patience. I grew up without a father in my life. By the time I was in my mid teens my father passed away from drug abuse. At that point I made a vow, based on my experiences with my father, that when I had children I would always be a positive influence in their life. So when my first son was born, even though I was a teenager, I made sure that I was there for him.

Fatherhood has been both rewarding and very challenging. As a father it is important to help guide and support your children. I am truly blessed to have six wonderful children, all of whom I love dearly and all of whom get on my last nerves periodically. We laugh and cry together, we go places together and sometimes I make sure that I go places without them. Last but not least, the most important thing for me as a father is to be there for all of my children.

Coming from not having a father, I knew that everything I didn't have I needed to do with my son. A child is the most important thing. Parents are supposed to be their kids' first teachers. They don't need to have the best clothes but making sure their noses are clean, that they have discipline and manners—certain things like that—are important.

You can tell a lot by looking at a child—how their house is kept, what is condoned in that house as far as discipline, whether or not they take pride in themselves. When you have love for yourself, you see it in that child, as a reflection of you. If you take any child and spend time, mold them, you get back what you put in. You can't plant apples and get bananas. While they're young, you have to prepare them for when they get older or for what they're going to be in the long run. If you talk to them, they'll listen.

Kids should be raised the way we grew up back in the day. If you look at the generation gap from the 80s and up, kids are a lot different in terms of manners, discipline, luxuries. Today, you can't touch them or be too stern because then someone will call ACS.

Time is the best medicine for children. They need to see you there every day. You can't be connected to something or someone if you're not around them.

NYRON

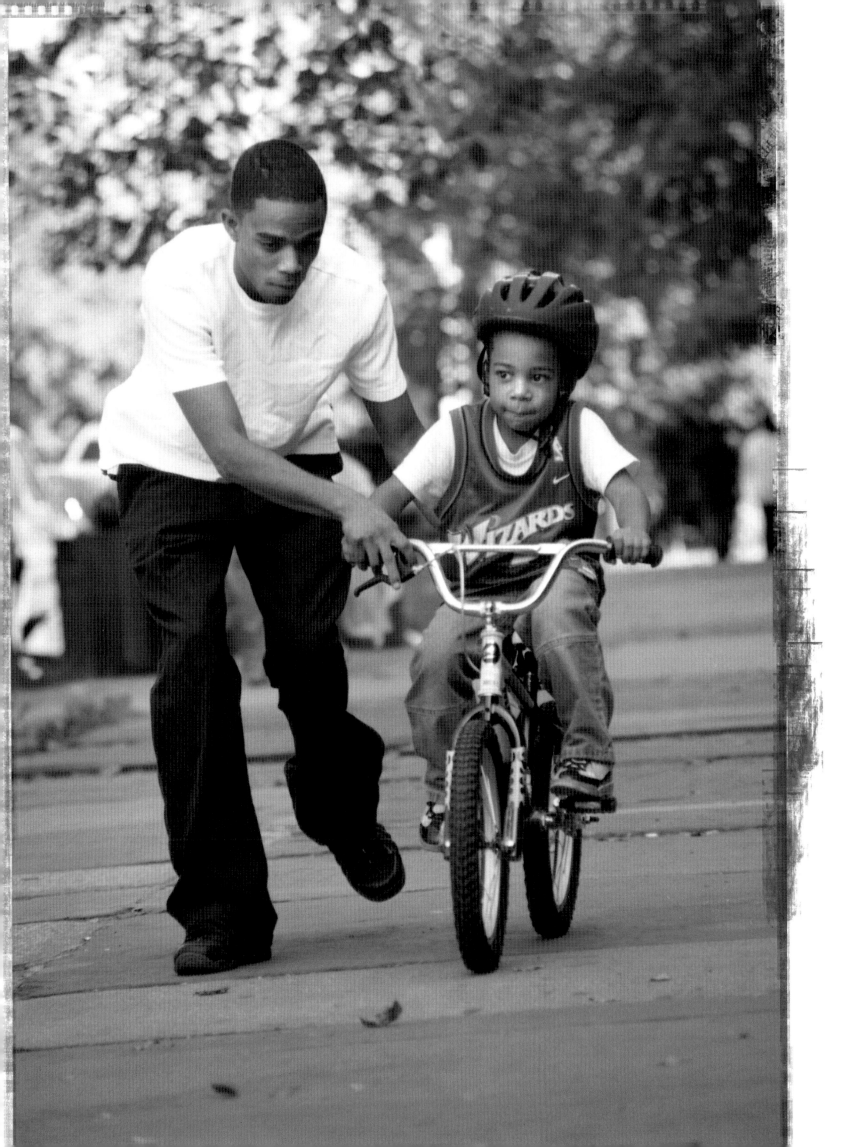

Being a father is the most humbling experience I have faced. It requires intense self-reflection and has consistently led me to an internal dialectic regarding my own strengths and shortcomings. I have had to completely rethink my actions and reactions contextually, and have become more selective regarding the battles I choose to fight. My children, in tandem with my wife, have provided a catalyst for me to elevate my consciousness, which from an Islamic perspective dwells in our hearts. Love, compassion and patience resonate when I look into the eyes of my sons, releasing the child within me.

Prior to the birth of our first son I never imagined the level of discipline, perseverance and integrity that would be required of me to raise a conscious Afro-Asiatic Muslim male in post 9-11 America. Our children's survival is incumbent upon many factors, one of the most significant being the relationship with their fathers. Give thanks and praises to the most high for the blessings that have been bestowed upon us all as fathers, and may we continually be provided with peace and guidance to raise them right insh'allah.

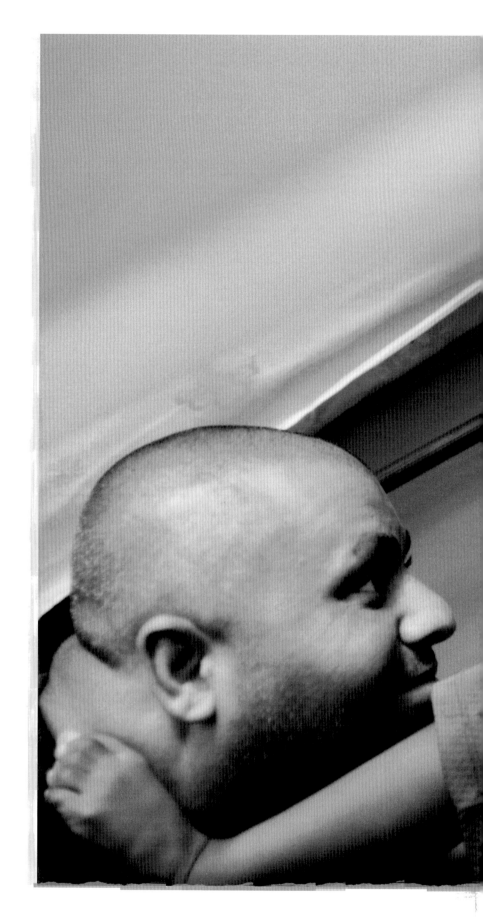

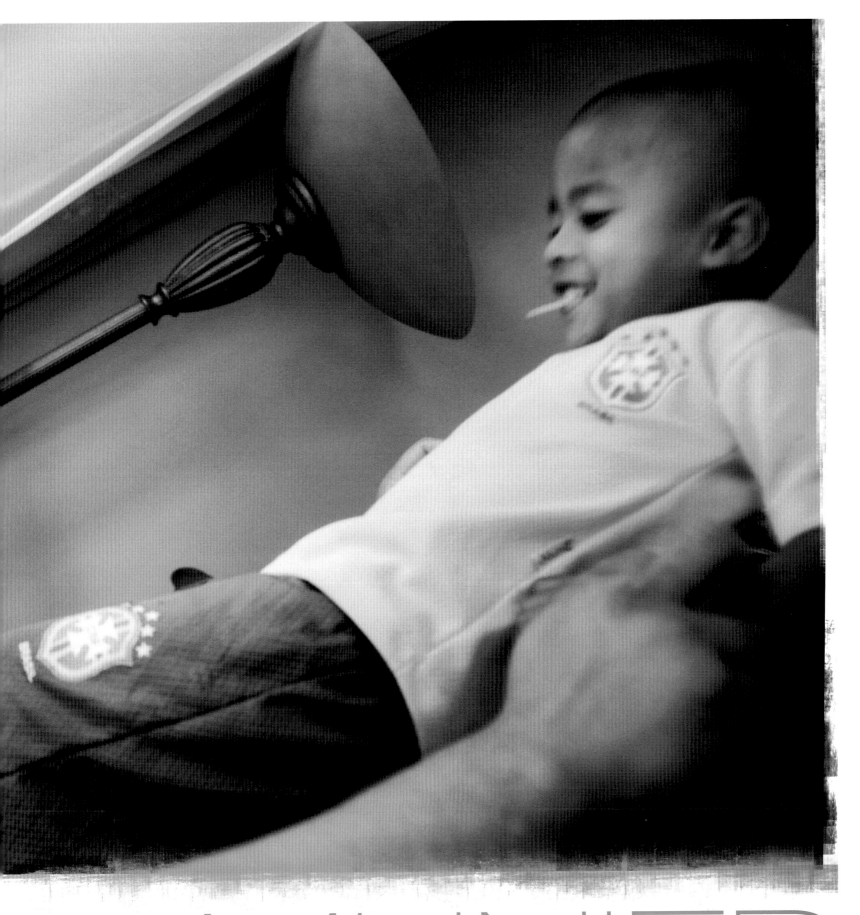

MUNIER

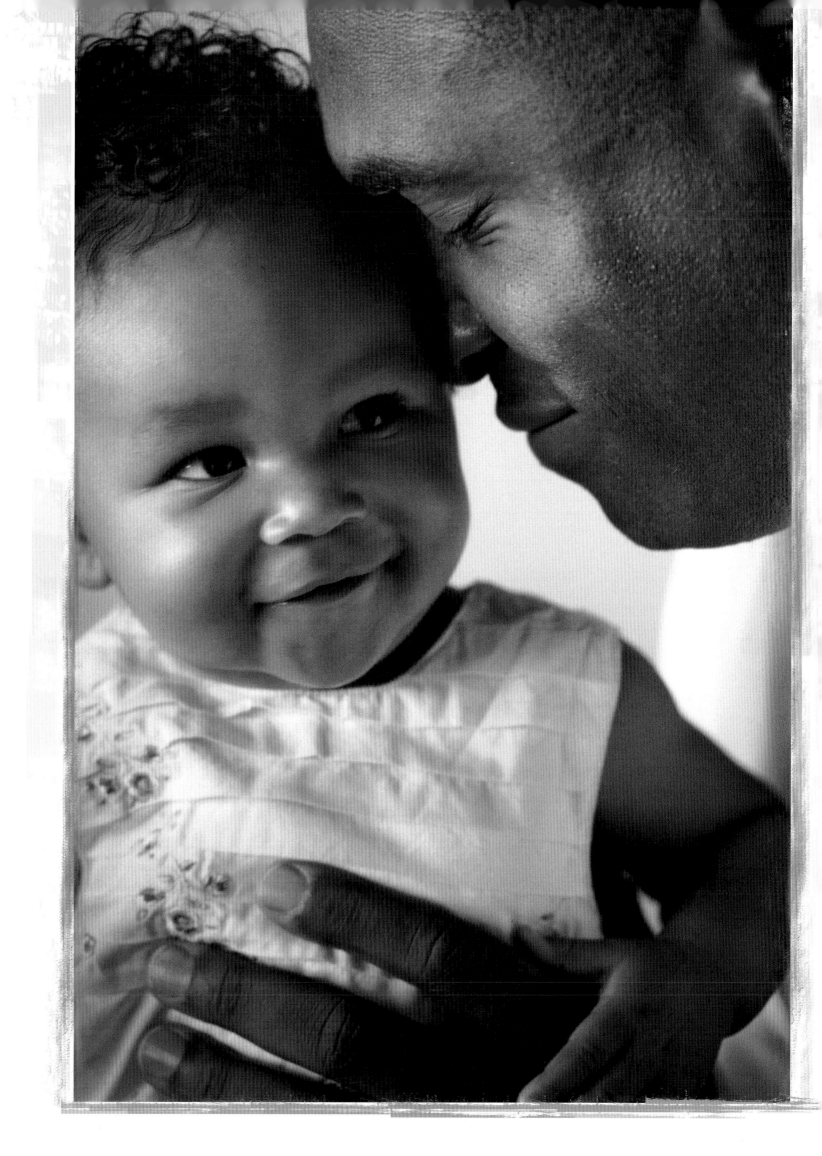

Reflecting on what I love about being a dad . . . between canceled flights and conference calls, emails, pages and faxes, I have not known a greater joy than to kiss my daughter's little toes with her snuggly and asleep in my arms, before the hectic day passes.

SHÁKA

The role of fatherhood is like an ocean, in the fact that it never ends and the current change is constant. It's beautiful and awe-inspiring, but at the same time it can be overwhelming and a little frightening. Imagine a child is thrown into the water; if you do not save him, he will drown. The problem is that you don't know how to swim either. You have seen other people swim, but you have never done it. But you jump in. You instinctively jump in. Both father and son are key to each other's survival. And you learn to be a father as you cross that ocean. Your sole mission is to protect that child. To make sure that child makes it to the other side. You learn, hopefully, to be a better man through the journey.

I can talk about fatherhood in many ways. But for me, it's been all instinct and heredity (maybe that is the same thing). There are some things I have taken from my own father that I have embraced and used with my son, but there are also other insights from him that I fight to keep away from this journey. I've grown to believe that fatherhood is not a perfect science. We make mistakes. But being there is what is important, I think. Being in the water with him so he knows he is not alone.

I so desperately want to be my son's best friend, but my role is to be his parent. I am sure that sometimes he sees me as dictator, obstacle, but always his protector and, more importantly, his mentor. He knows that. As we play, and life springs through his wonderful spirit, I am so glad I jumped in.

MAURICE

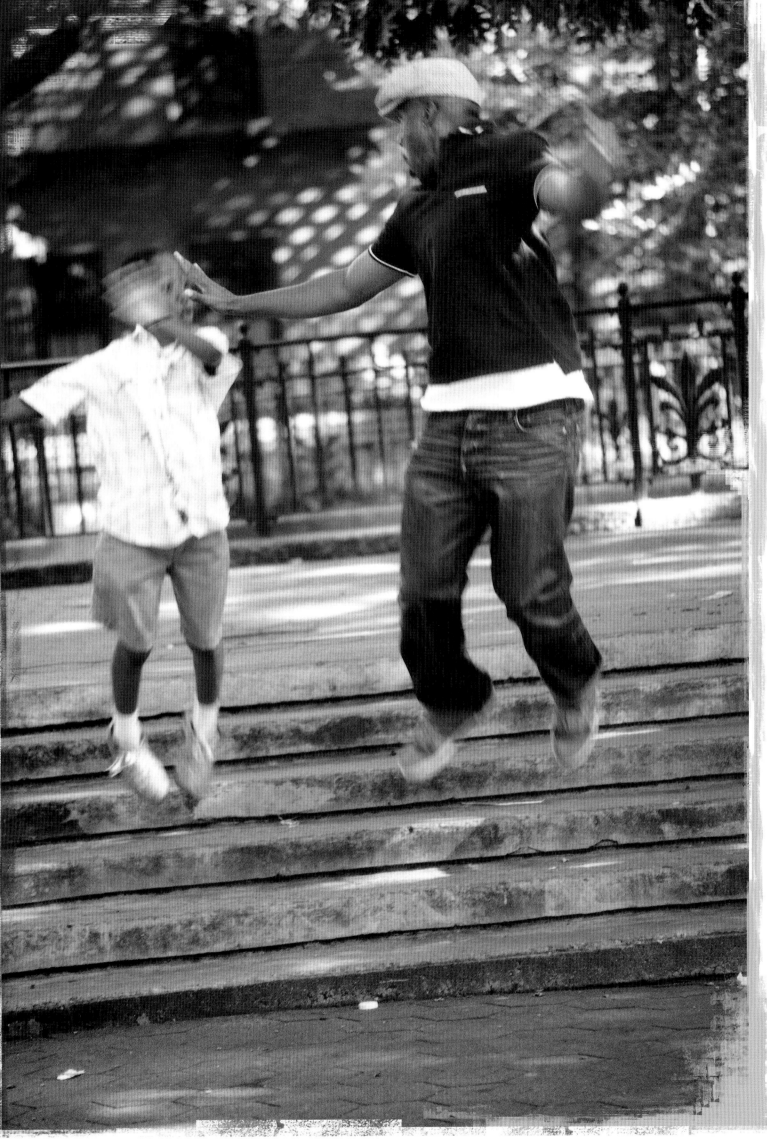

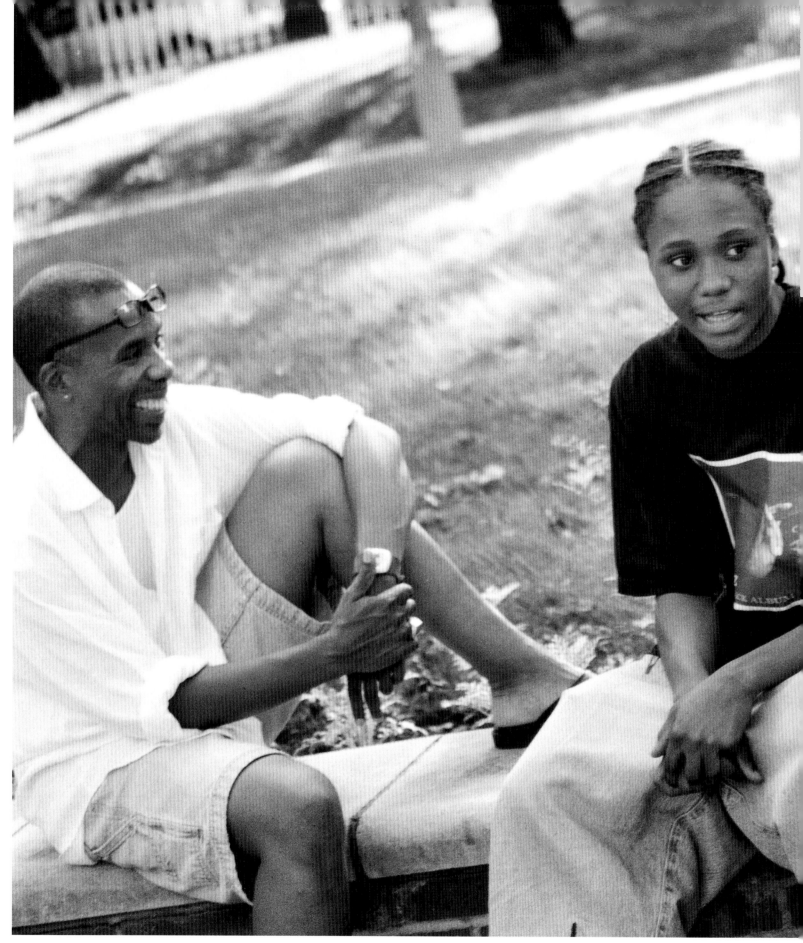

LARRY

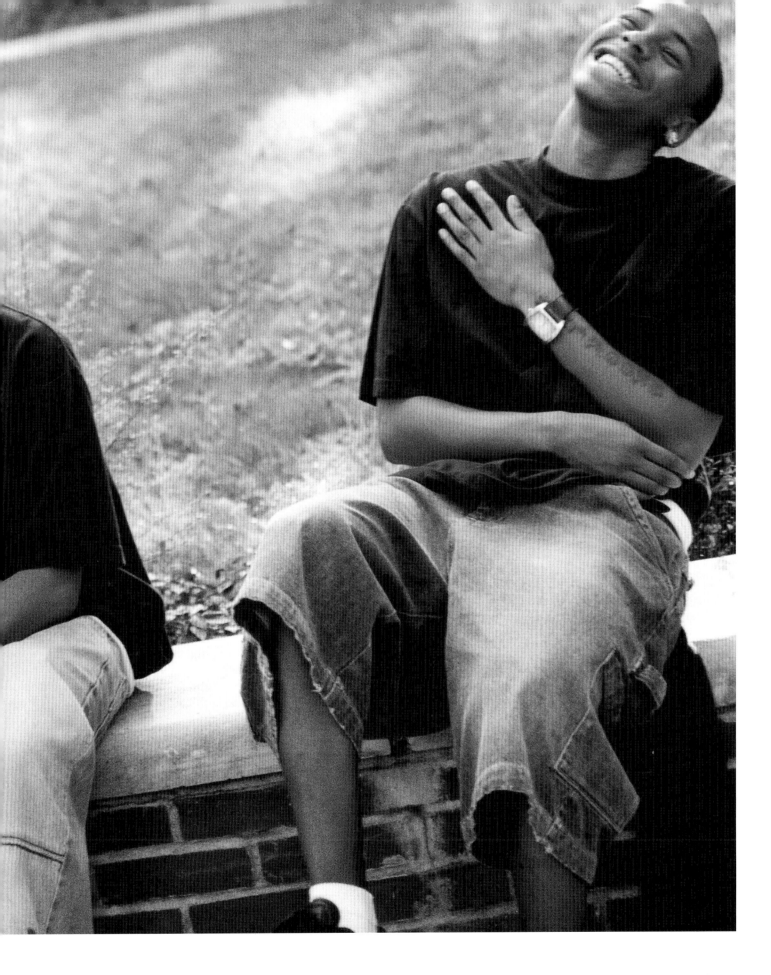

It was not until I had sons of my own that I realized how much my father loved me. To describe the experience

of the birth of my children would be like trying to consume the oceans of the world with a soup spoon. I think

fatherhood is a joy all men are entitled to.

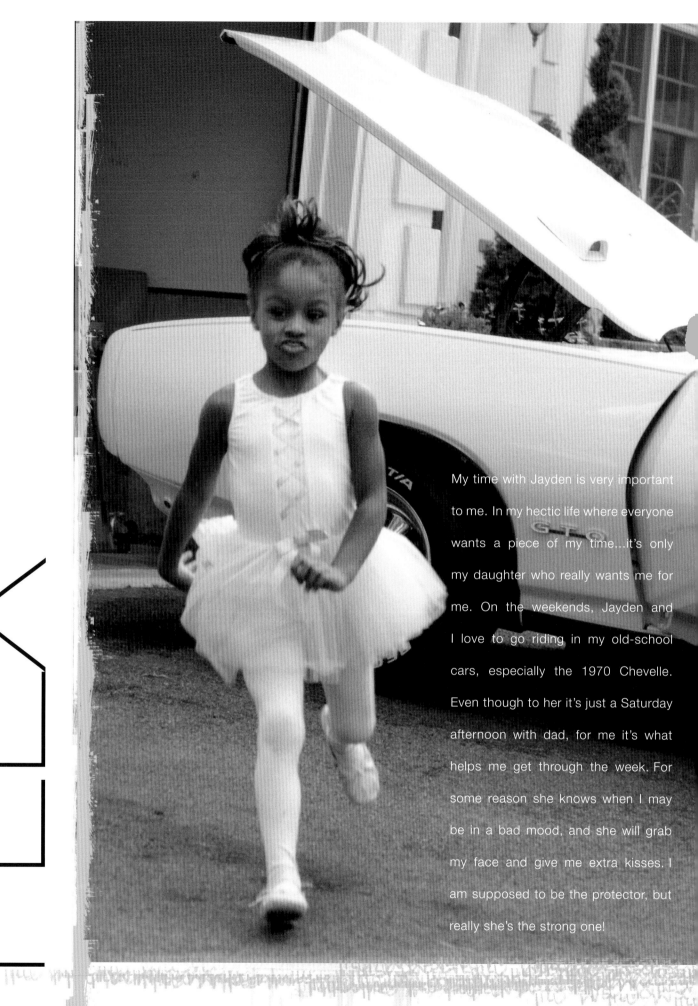

FLEX

My time with Jayden is very important to me. In my hectic life where everyone wants a piece of my time...it's only my daughter who really wants me for me. On the weekends, Jayden and I love to go riding in my old-school cars, especially the 1970 Chevelle. Even though to her it's just a Saturday afternoon with dad, for me it's what helps me get through the week. For some reason she knows when I may be in a bad mood, and she will grab my face and give me extra kisses. I am supposed to be the protector, but really she's the strong one!

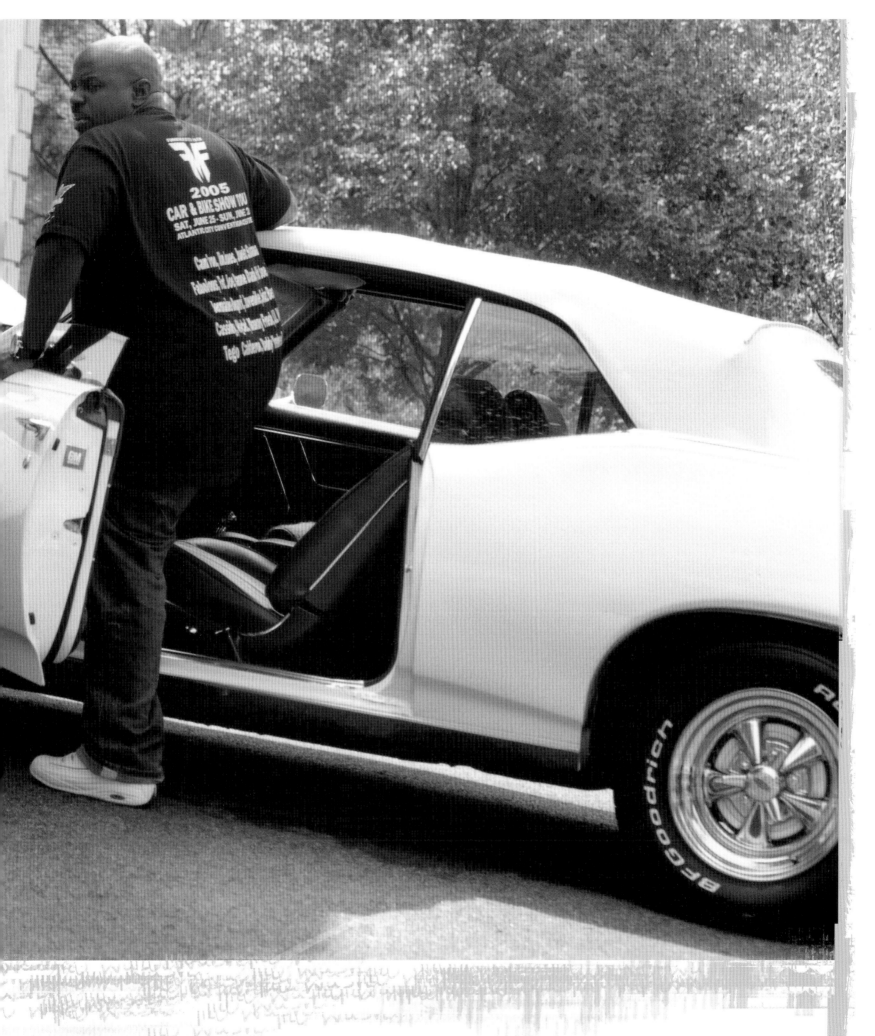

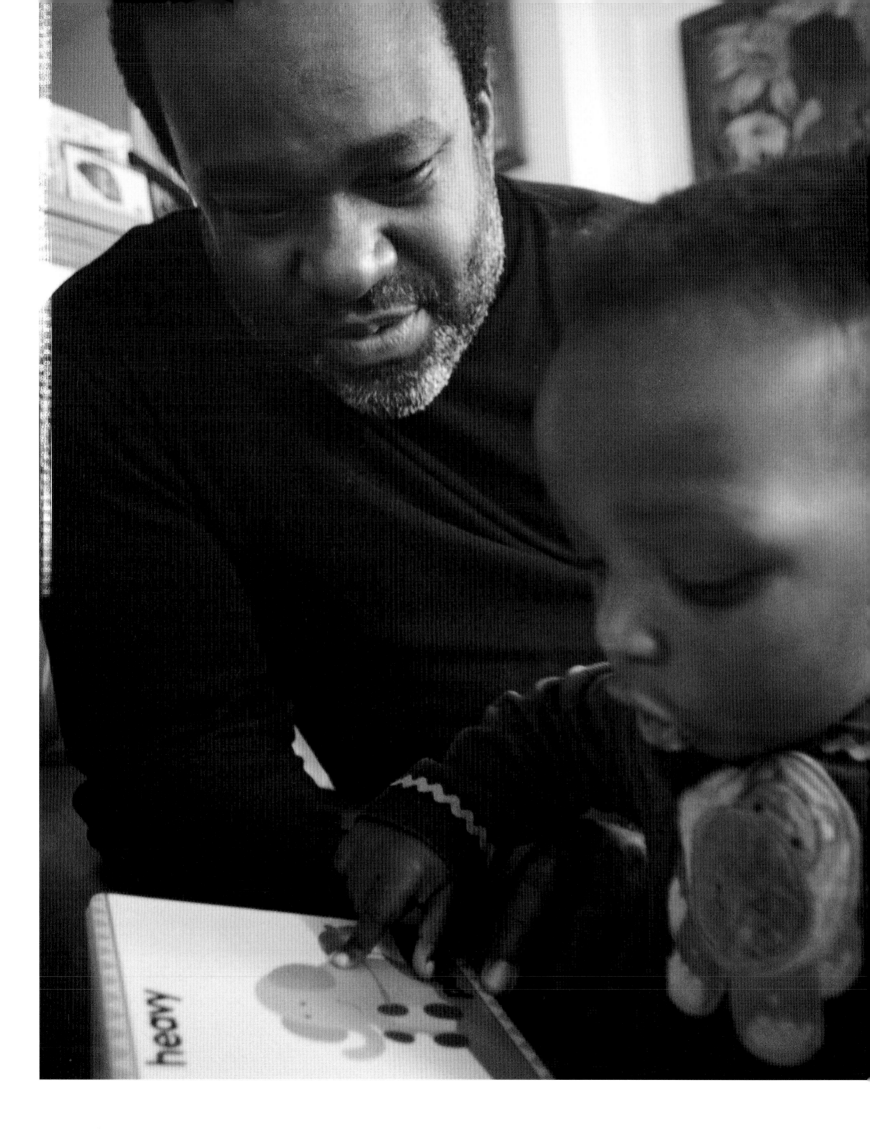

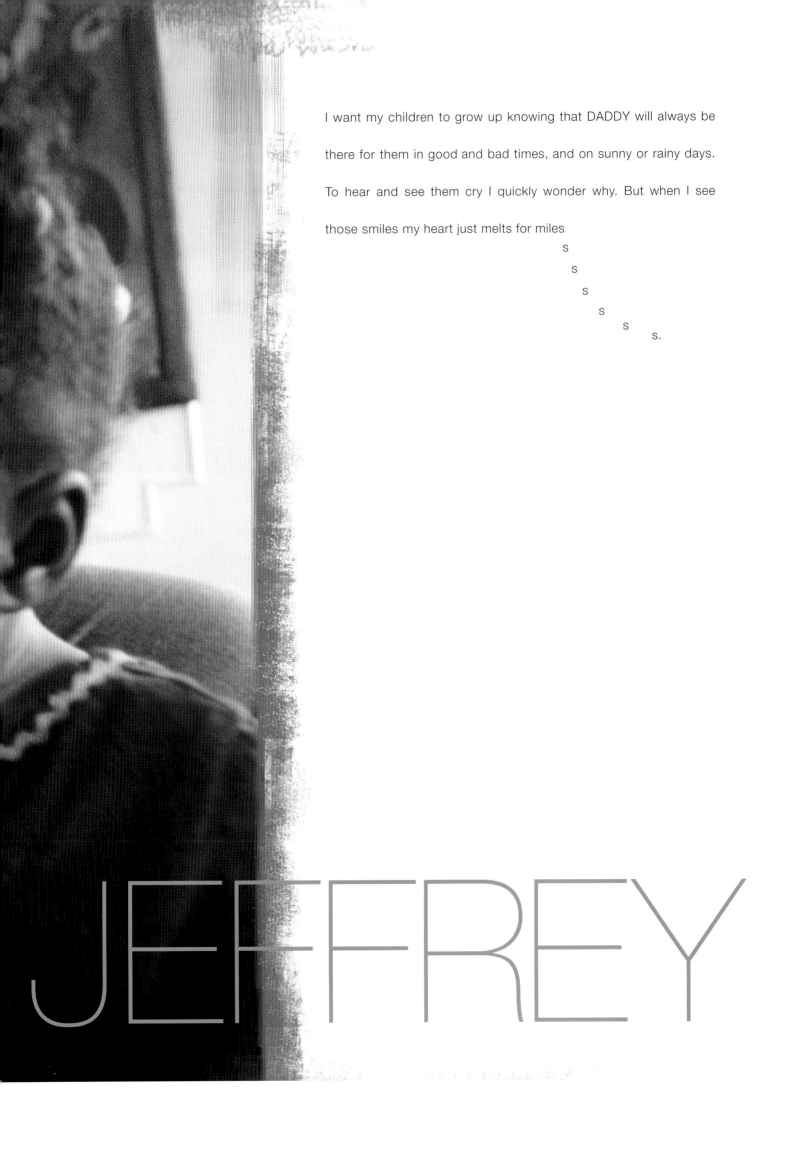

I want my children to grow up knowing that DADDY will always be there for them in good and bad times, and on sunny or rainy days. To hear and see them cry I quickly wonder why. But when I see those smiles my heart just melts for miles

s

s

s

s

s

s.

JEFFREY

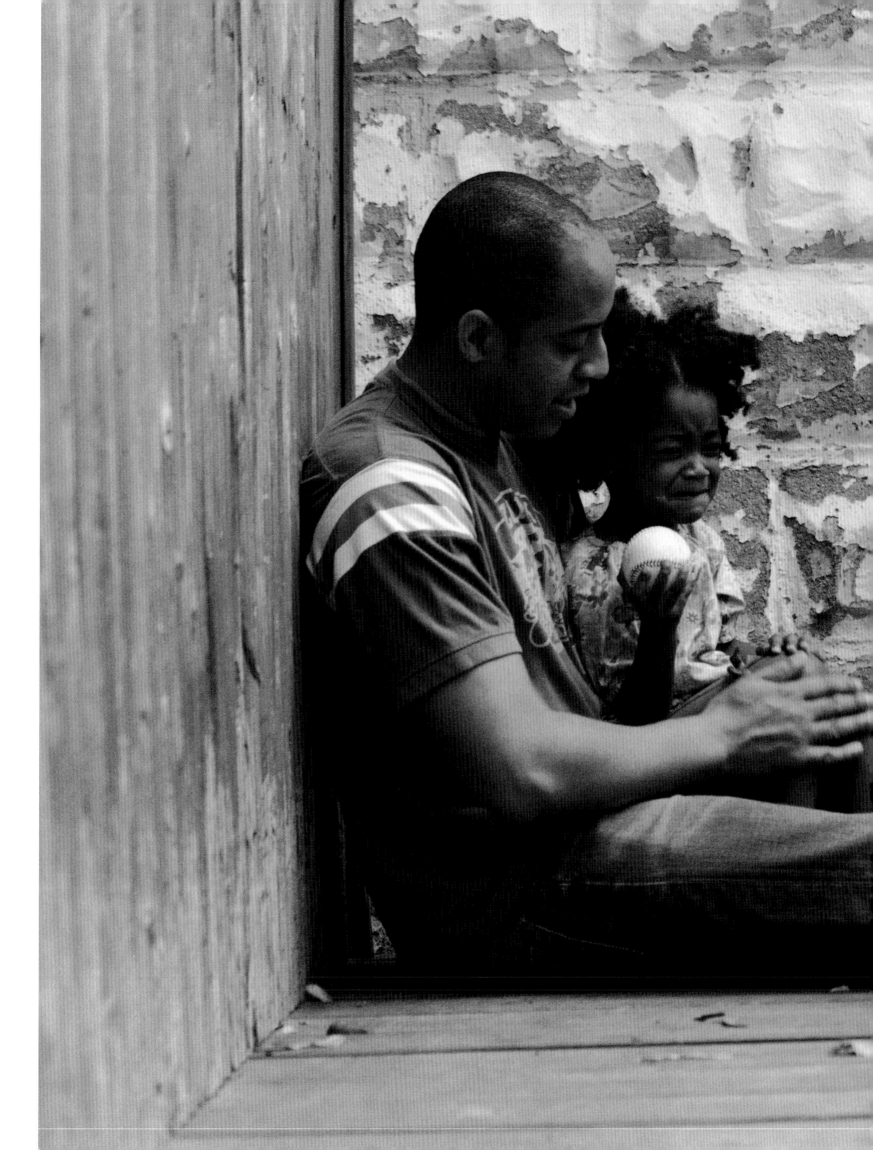

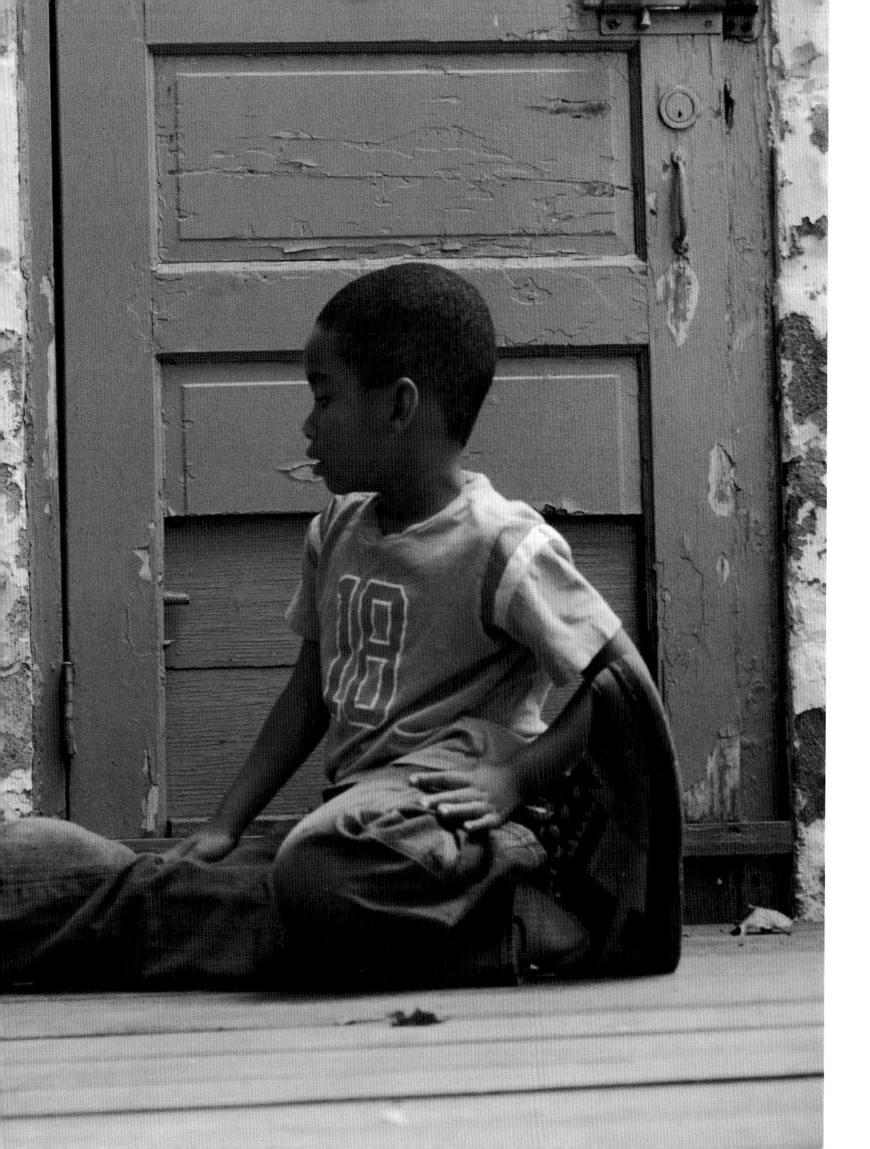

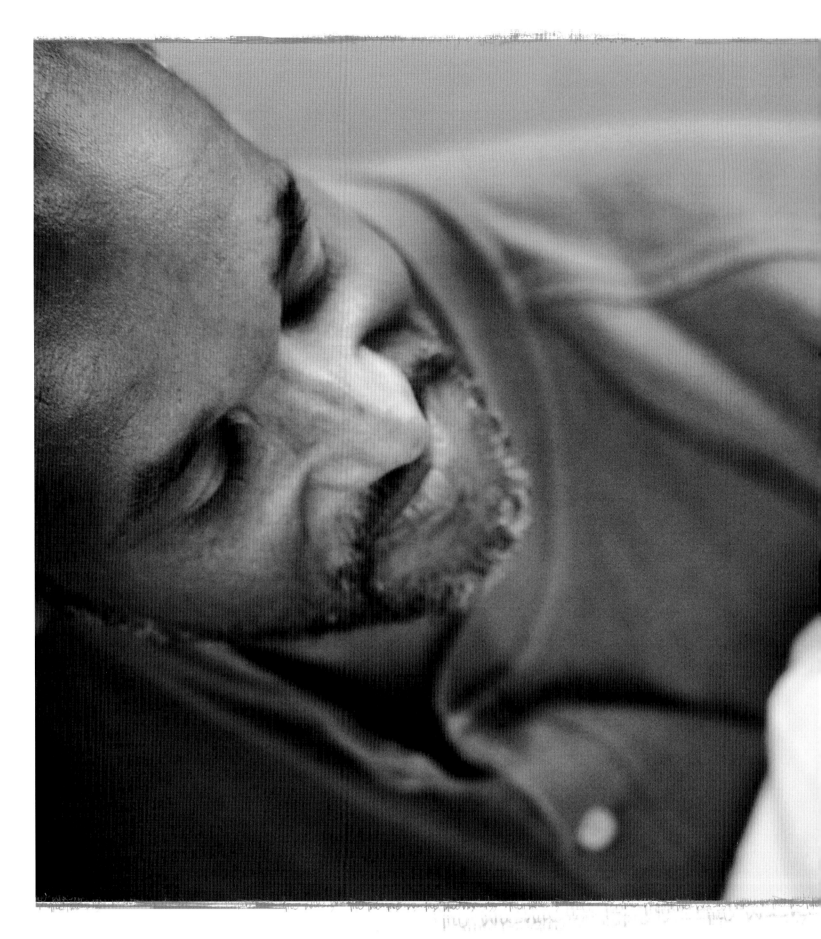

SEAN

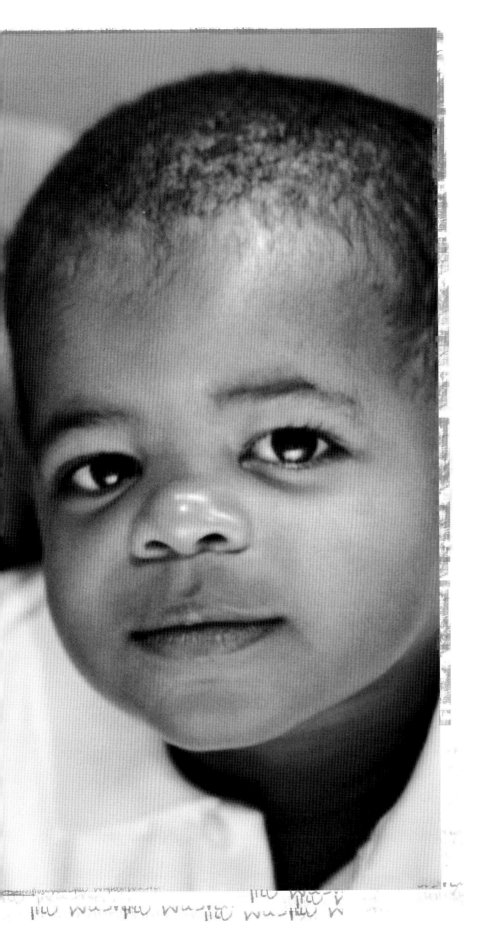

Dear Michael Callan,

I didn't know what it would be like having a son. I can remember the exact feeling I had when I first held you in my arms the morning you were born. When our eyes first locked on each other, it ignited a range of emotions which I never experienced before. Although your mom and I asked the doctors to protect your identity from us during the pregnancy, I knew it would be a son, my son!

My love for you son is unconditional, unwavering, complete, unequivocal and uniquely masculine! I am your biggest fan to ensure that you will be armed with every advantage to exceed all your dreams. But I am also your biggest disciplinarian. I know I only have your attention for a short time, so I must take advantage to pour all I know that is good into your soul that will carry you for your life's journey. You are a gift and I must be accountable to God with my time with you. I cannot afford to be your buddy—I am your father, I have to make this work. It is my responsibility to set the tone for boundaries and foundation for your character. You are my only child, thus you are my only legacy and investment.

I often wonder what challenges you will encounter as you develop into a man—nothing is new, just different. So don't sweat it. I will not be able to shield you from the challenges I don't even know yet for myself. But if I do my job correctly you will know what is right and wrong and choose for yourself. I pray that you will hold onto those influences that build, bind and strengthen your relationship with God. I don't expect you to make all the right decisions all the time but I hope you will admit your wrongs and not be afraid to fail.

I understand statistics show that most kids that look like you never have an opportunity to know their fathers and have a relationship. That saddens my heart. Callan, let's set an example for the world of what a father/son love relationship should be!

Many folks have paved the way for you, including your mother and me and your grandparents. You are a part of a rich heritage, Callan, but you have to accept it and want to contribute to it. I am not putting anything on a silver plate for you. You will have to prove yourself through your actions.

You have a whole a lot of living in front of you. I will be there every step of the way. And, of course, we have lots of ballgames to play cause "Life is a ball!"

Always, Dad

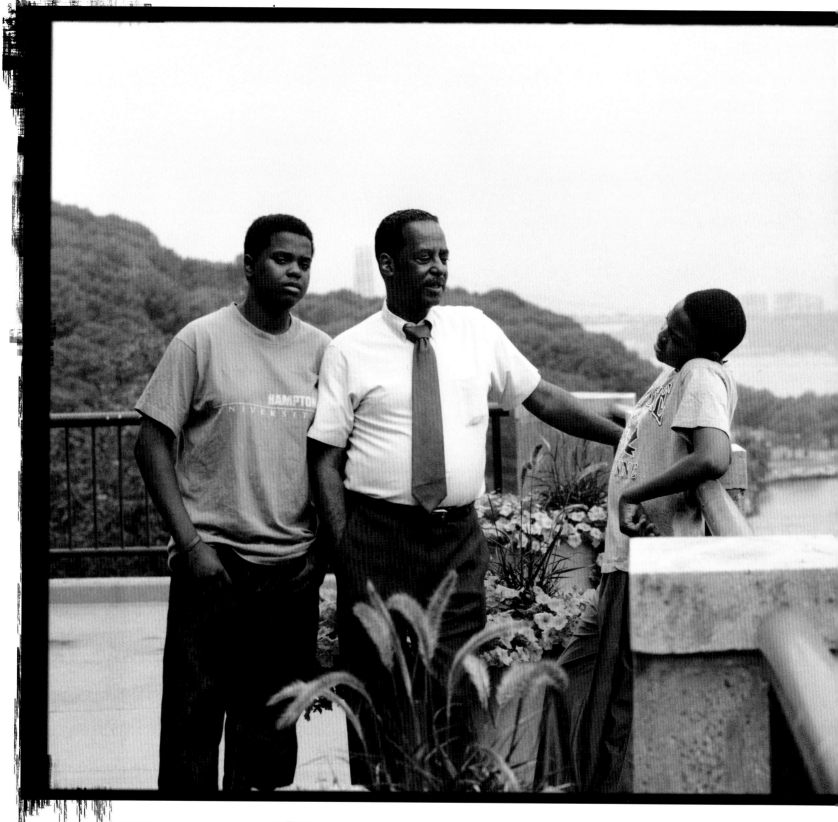

RONALD

Someone gave me a T-shirt for Father's Day that read, RESPECT THY FATHER, He is all knowing. Well. I don't know about all that, but I do know a few things about fathering because I was blessed to have a father like Herman Lee Cook.

I often tell the story about my father wanting to get my son, Samuel, a toy for Christmas in 1992. Dad made it his business to go to a toy store and purchase a Barney mobile, because he knew that Sam loved Barney. He called me to come get the toy and assemble it and, if possible, let him see it before I carried it to Washington D.C., where my wife, Suzan, was working. My wife had been in Washington for almost a year as a White House Fellow, and I was commuting each weekend to see her and my son. This particular weekend in January, I was headed for the plane at LaGuardia, when I realized the weather had forced US Air to cancel flights for a few hours.

I decided to take the train to Washington so I got a cab and headed for Grand Central in Manhattan. As I crossed the Triborough Bridge, something told me to stop by my father's house, which was on the way. My dad was sitting at the table playing solitaire, his favorite game. We talked a few minutes. Dad, I said, I want you to see the toy you got for Sam. His eyes lit up in surprise, and a smile came across his face. I pulled the toy out, and gave it to him. He was so pleased that he purchased this toy for his grandson, and he looked it over, smiled again, and gave it back to me.

I arrived in Washington that evening. The next day, Suzan and I were in the family room with Sam, as he played on his Barney mobile. He was riding around the room laughing and smiling as if someone was playing with him. A few minutes later, I received a phone call from a doctor at the North General Hospital and he told me that my father had just died from heart failure. He said that he died quietly in his sleep; he was at peace.

My son is fourteen years old, and I try to be the kind of father to him that my father was to me. Love your children, fathers, hug them every chance you get, and tell them you love them, before it is too late.

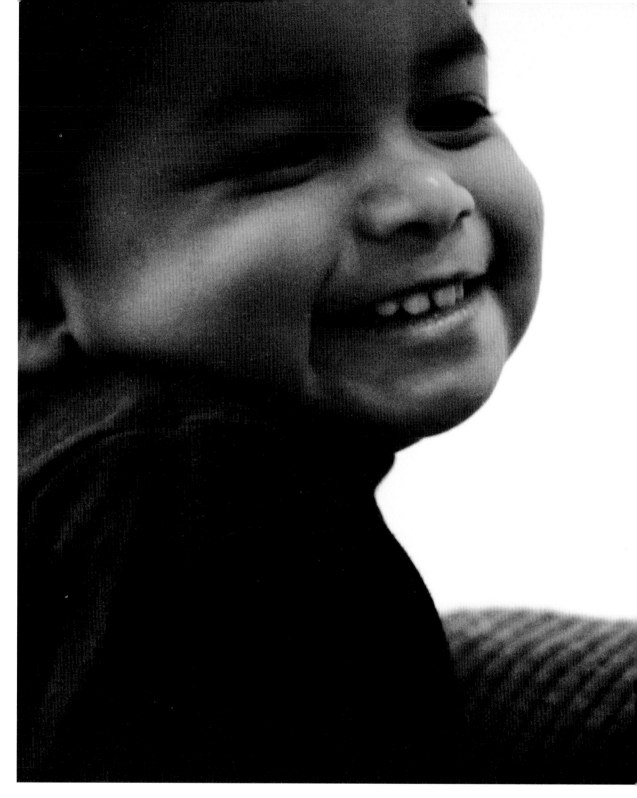

AMADOU

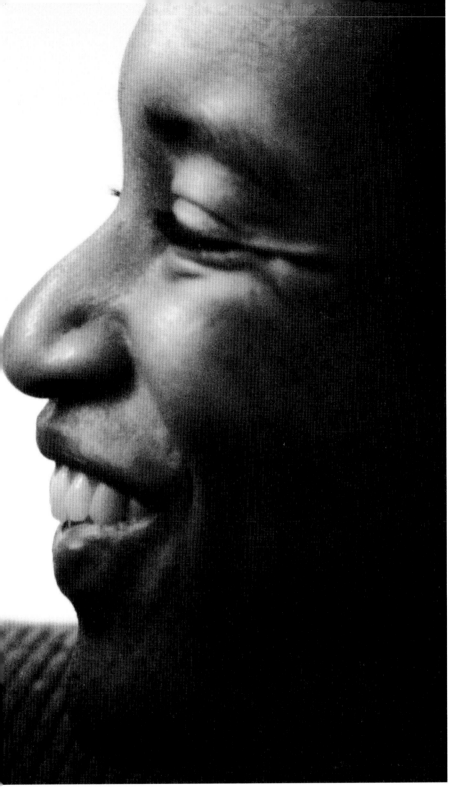

Being a father means:

Feelings of newfound appreciation for the gift of life.

Aspiring to be the man that my son deserves.

Taking on the responsibility for shaping and developing a life

which arrives with limitless potential.

Having the father-son relationship I never experienced as a child.

Experiencing the world through a new set of eyes, appreciating

the daily wonders that often go unnoticed.

Receiving and sharing love unconditionally.

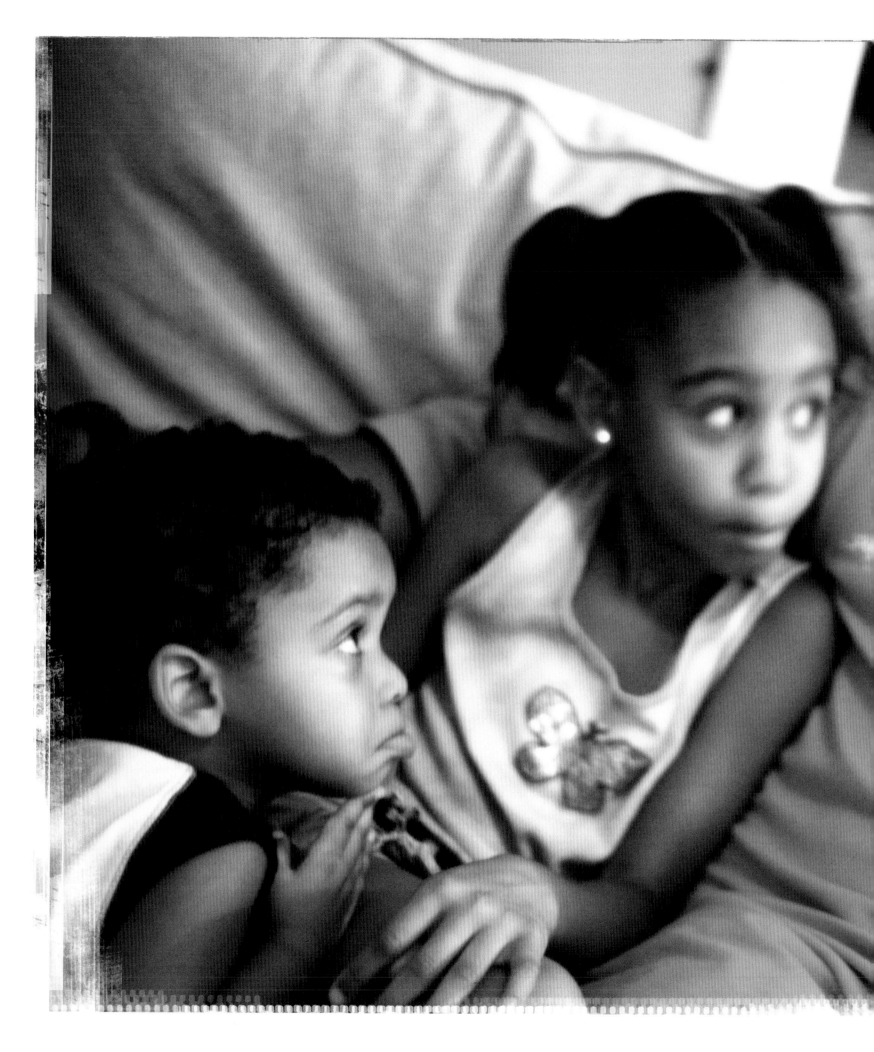

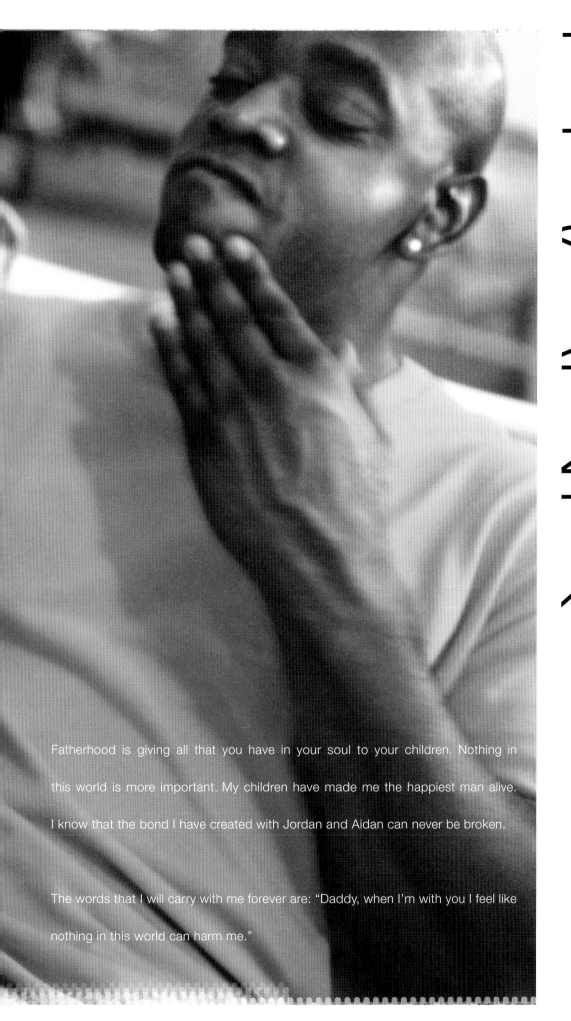

FRANK

Fatherhood is giving all that you have in your soul to your children. Nothing in this world is more important. My children have made me the happiest man alive. I know that the bond I have created with Jordan and Aidan can never be broken.

The words that I will carry with me forever are: "Daddy, when I'm with you I feel like nothing in this world can harm me."

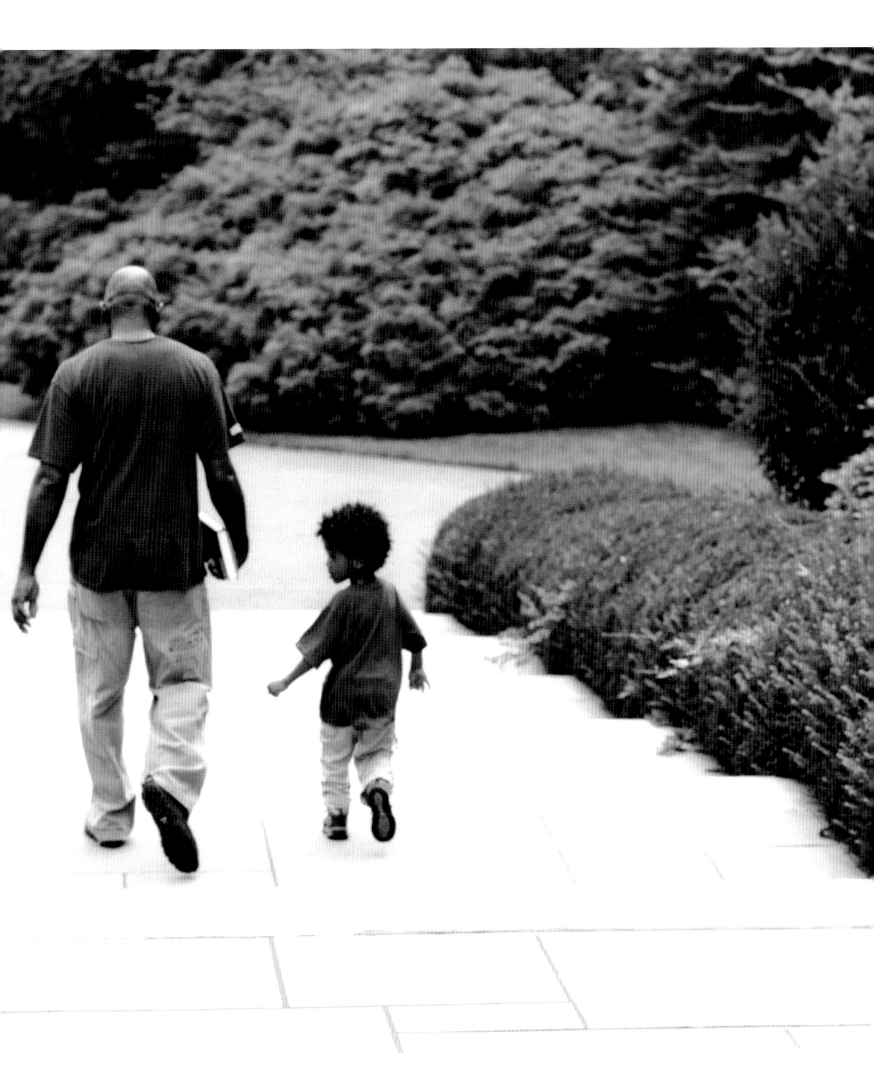

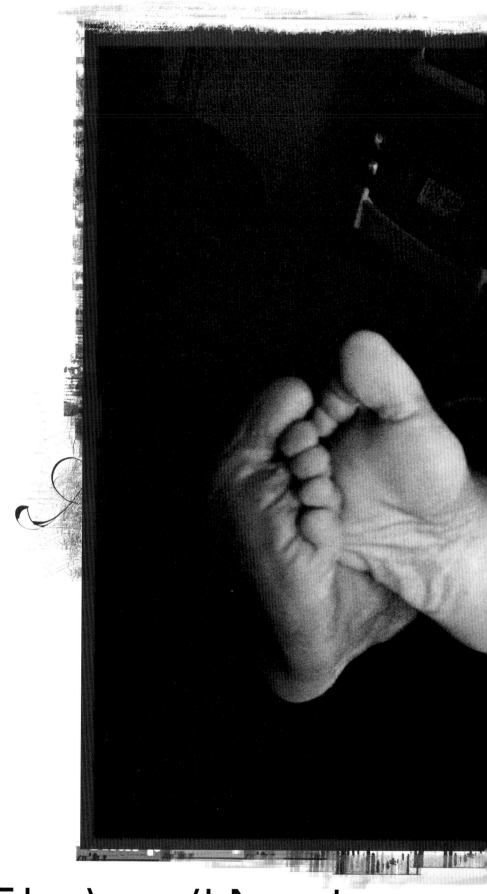

INT. LIVING ROOM-DAY

A Volkswagen bus is parked in the wall.

Melvin and Mario contemplate fatherhood.

MELVIN:

Ah, ask my kid...

MARIO:

A father must be who he says he is.

MELVIN

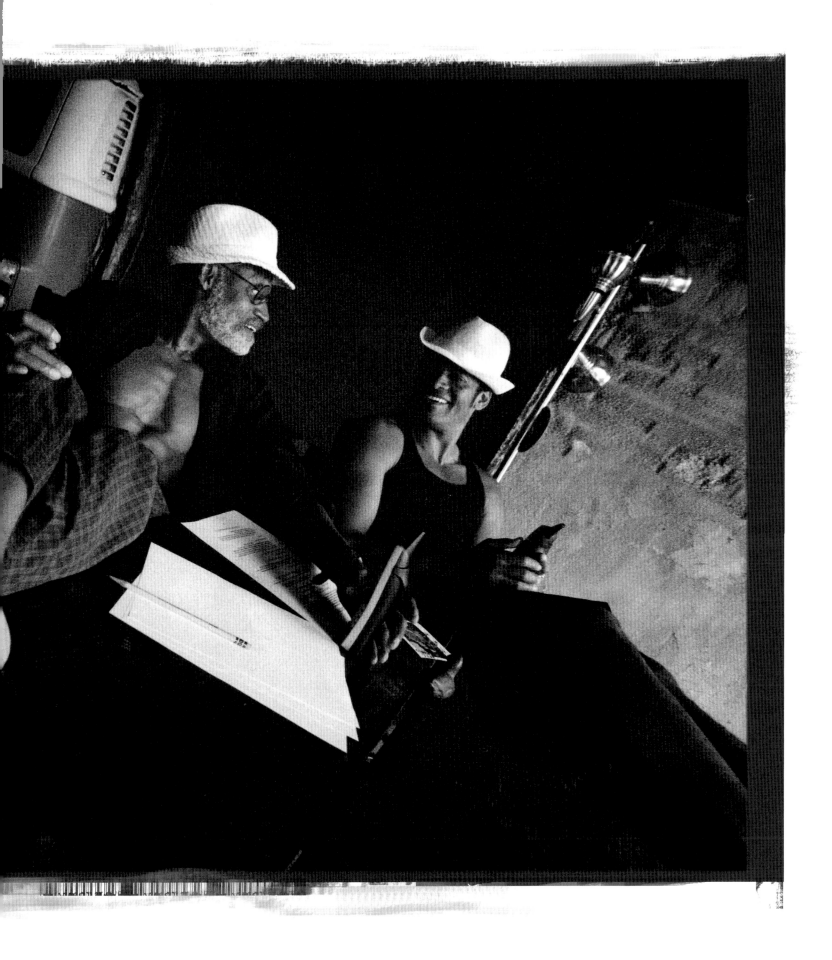

NIKON

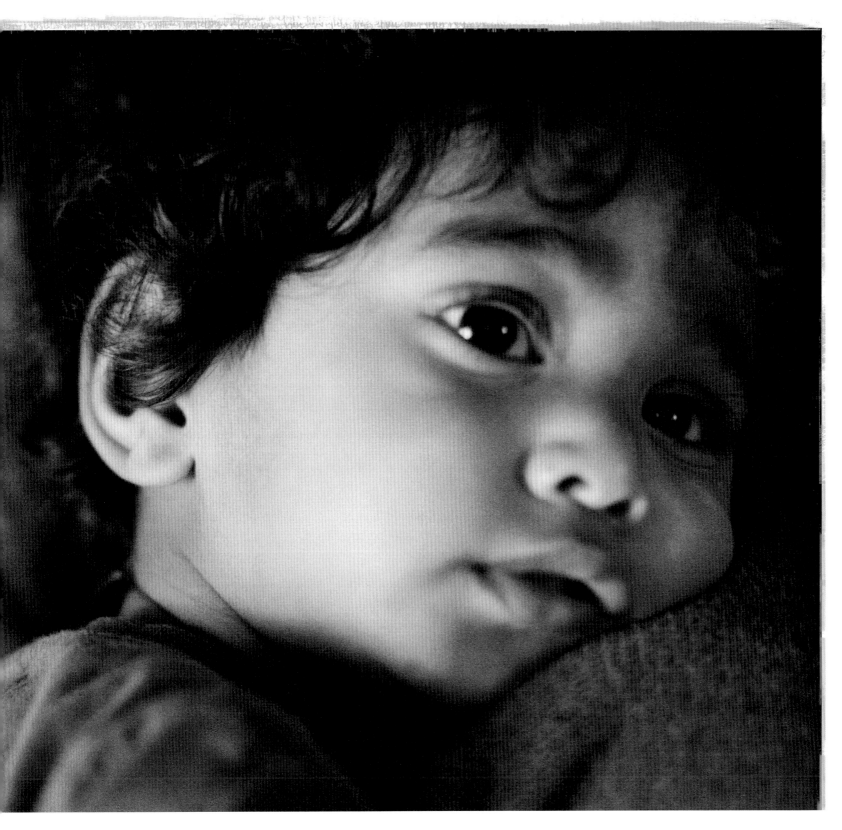

My son is a constant joy but he's work. I'm not just talking about the work necessary to maintain his immediate needs and wants. He's work because I have to constantly remind myself that as much as I would like to relax around him, he is a full-time job. I remind myself that my role has to be more than just a disciplinarian. I have to cultivate his development, nurture his heart, encourage his mind and yes, when necessary, discipline him. In many households the mother is the primary parent and the father's role is secondary. Including taking care of all of the household duties, she might also have to be the bread winner. I never want to be a sideline father; being in my son Rakesh's presence is too fulfilling for that. He needs to see me as a constant in all aspects of his life. He needs to know that neither his father nor mother is afraid to put the work in when it comes to his development.

Fatherhood has been an awesome experience for me. I truly cannot wait for our daughter to get up every morning to hug and kiss her. Gabriella is almost four years old and is like a sponge. I want to share every aspect of my life with her while she is in this most accepting period in her life. Gabriella frequently accompanies me when I volunteer with various community organizations. We look forward to this bonding time while helping those that are less fortunate in our community. I believe this will be integral to her development as a person. She will know how blessed she is while having compassion for others.

I want Gabriella to emulate my deeds. This is not always easy because there are so many pressures on African-American males, but I feel as though I must succeed. I know that I will, because my daughter thinks so much of me and I cannot let her down. I am concerned about her future. Not her personally, but with so many African-American youths, particularly males, making bad decisions, there will be limited peers for her. This is one reason why I volunteer so diligently with youths. I am so looking forward to raising Gabriella, to seeing her laugh, cry, grow, explore, learn, love, hurt and worship, for her to know that her parents love her and will always be there for her.

JUAN

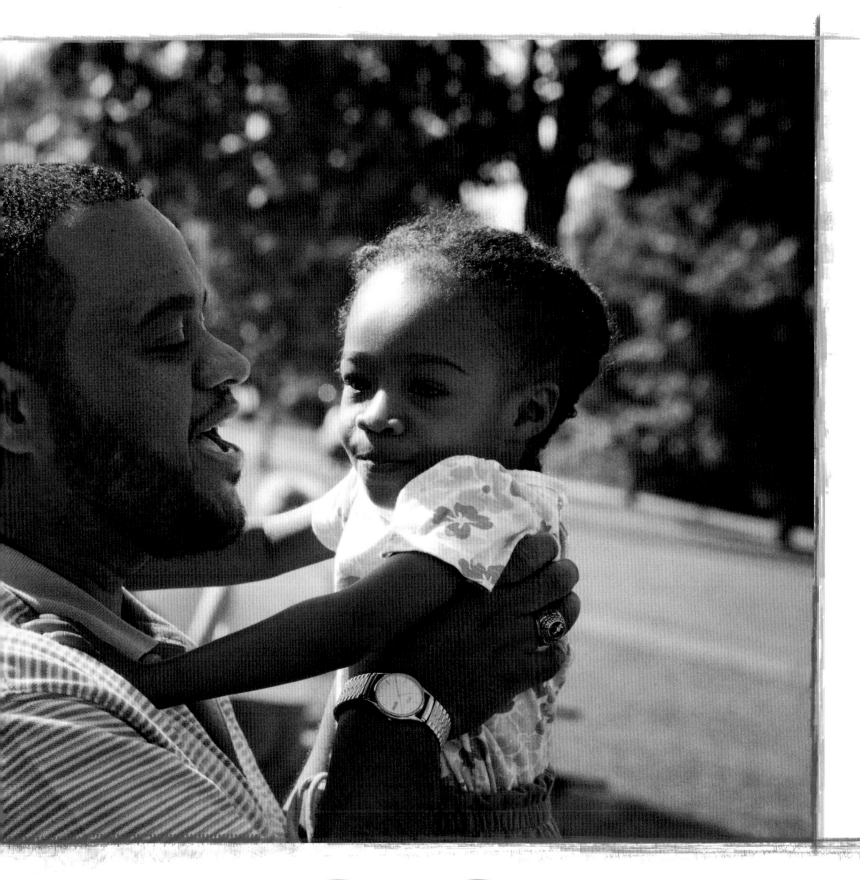

DIEGO

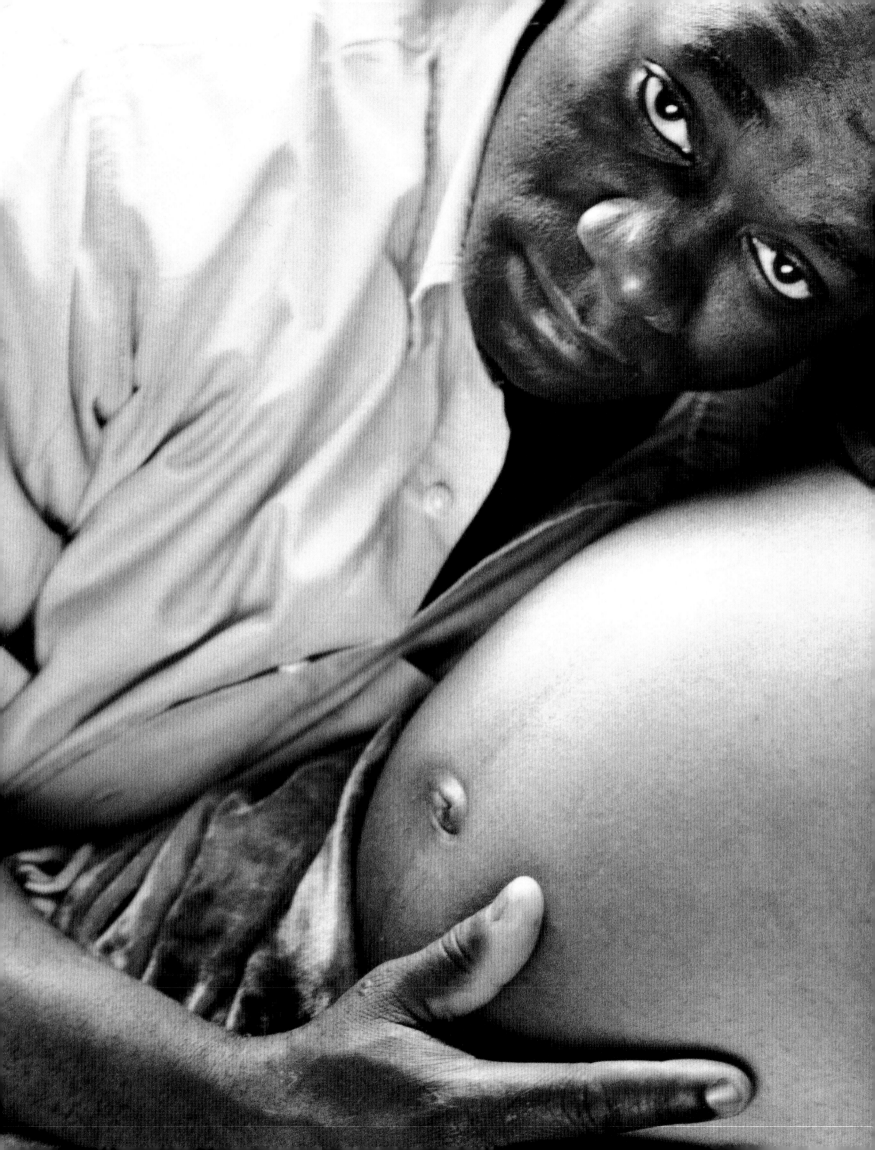

Waiting for your first baby is full of expectation and worry. You hope for a safe and uneventful pregnancy for the mother. How will life be in the future? Within this new life lies love, hope and happiness. Better planning, perseverance and anticipation should lead to a new tomorrow. Always balance your life and your expectations.

Whenever you feel stressed in any way, think about your expectations and how they might be contributing to your problems. The more you learn about your hidden expectations the more power and control you will gain in relation to them. Always ask yourself if something might be wrong or incomplete with any specific expectation you have. Just by asking yourself this very simple question, you can empower yourself to see things in new, and hopefully more accurate, ways. The more you are able to do this, the less stress and tension you will ultimately have. Free your mind; live your life in peace. The birth of a child is a welcoming moment and with it comes happiness and much success.

MORY

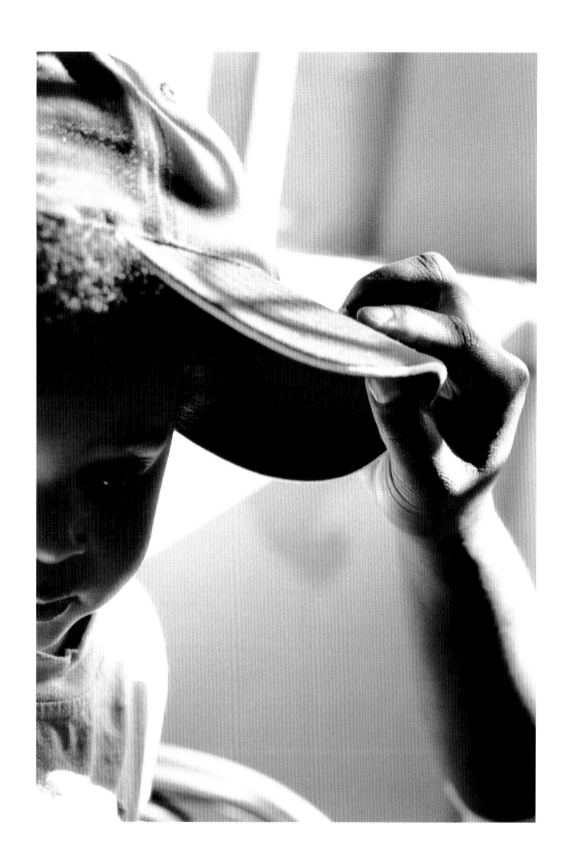

Biographies

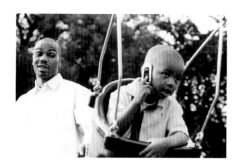

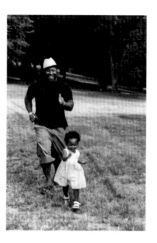

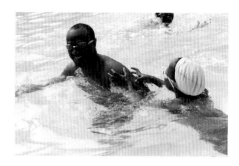

Gordon M. Jackson, 34
Sales
Born in New Orleans, LA,
raised in PA, MA, and NY
Kairo

Myke Murray, 37
Manager-Health and Fitness Facility
Born in Bronx, NY, raised all over
the world
Amber, Sophia, and Ella

Kendrick Edwards, 41
Pastor, Sales Clerk-U. S. Postal Service
Born in Joliet, IL
Bernice and Jean (twins), Christen
and Shelby (twins)

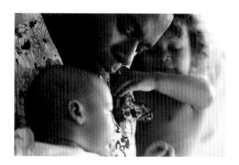

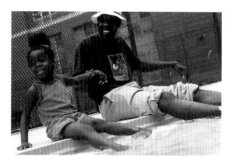

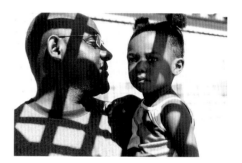

Malik Williams, 42
Music Marketer
Born and raised in Boston, MA
Milo and Khalil

Doug E. Doug Bourne, 30ish
Black Superstar
Born and raised in Brooklyn, NY
Faith

Ibrahima Diomande, 43
Music Manager, Driver
Born and raised in Abidjan,
Cote d'Ivoire, West Africa
Fatima Lauryn

Howard Askins, MD, JD, 43
Psychiatrist
Born in Brooklyn, NY, raised in
Queens, NY
Jordan, Noel, Sloane, and Luke

George J. Harris, 50
Supervisor of Charlottesville
Transportation
Born in Philadelphia, PA, raised outside
of Charlottesville, VA
Scott A. Fortune and Christopher

William Grant Bumpus, Jr., 47
Assistant Attorney General for the State
of Connecticut and Adjunct Professor at
Central Connecticut State University
Born and raised in Kansas City, MO
Kirby Lynette and William Grant III

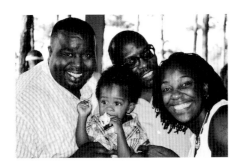

Monty Ross, 49
Producer / Special Projects Coordinator
Born and raised in Omaha, NE
Shenazar, Niema, and Austin

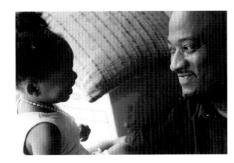

Bryan B. Collier, 39
Artist
Born and raised in Pocomoke City, MD
Haley Faith

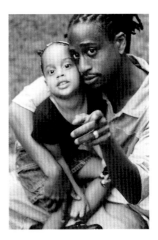

Damani Harrison, 27
Musician and Youth Counselor
Born in Sacramento, CA, raised in
Philadelphia and Germany
Iman

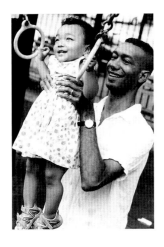

Roger Fortune, 42
Real Estate Development
Born and raised in Chicago, IL
Cooper Jung

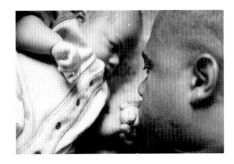

Greg Gunn, 36
Founder of an Educational Software
Company
Born in Chicago, IL, raised in Stanford,
CT
Gabriel

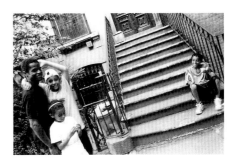

Charles Maurice McMickens, 46
Self-employed Restaurant Owner / Real
Estate Developer
Born and raised in Brooklyn, NY
Clay Montgomery, Reed Garrels, and
Grace Hennessey

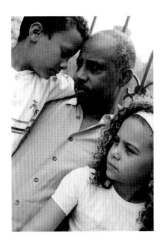

Ruben Santiago-Hudson, 49
Actor, Writer, Director
Born and raised in Lackawanna, NY
Broderick, Ruben III, Trey, and Lily

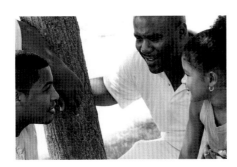

Jeffrey David LaVar, 42
Math Teacher
Born in Mount Vernon, NY, raised in Bronx,
NY
Oliver and Valerie

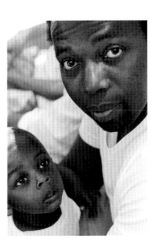

James Dewayne Wilcox, 46
Film Editor, Director
Born and raised in Pittsburgh, PA
Jaime

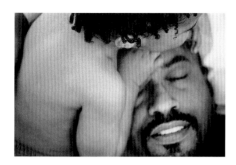

Chuck Vinson
Director
Born in South Bend, IN, raised in Elkhart, IN
Spencer, Charlotte-Mekhi, and Bryce
Rallen

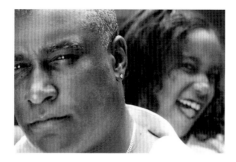

Michael D. Vann, 49
Entrepreneur, Commercial Developer
Born in Chicago, IL, and raised in Gary, IN
Sydney

Jeffrey Tweedy, 42
President of G-III Fashion
Born and raised in Washington, DC
Basil and Miles

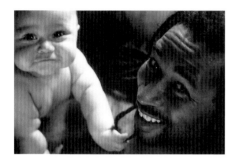

René Armando Collins, 43
Musician, Performer, and Teacher
Born and raised in Fort Ord, CA
Zukariy Wise

Tony Bolton, 49
Cable Television Executive
Born and raised in Washington, DC
Phaethon and Jacobi

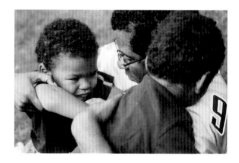

Malcolm D. Lee, 36
Film Director, Screenwriter
Born and raised in New York, NY
Langston and Lennox

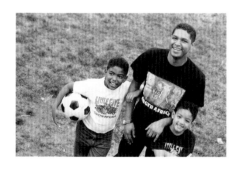

Dominic John Mentor, 38
Doctoral Candidate in Instructional
Technology
Born and raised in Cape Town,
South Africa
Timothy Lionel and Joel Peter

Antonio L.A. Reid, 48
Record Executive
Born and raised in Cincinnati, OH
Aaron

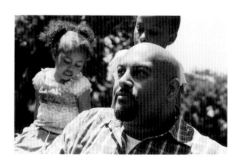

Chris Daniels, 39
Social Worker
Born and raised in Brooklyn, NY
Maiya and Kayla

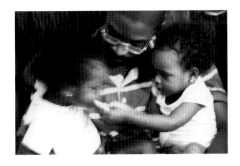

Siddiq Theodile Bello, 35
Digital Entertainment Consultant
Born in Long Island, NY,
raised internationally
Sonali and Subria

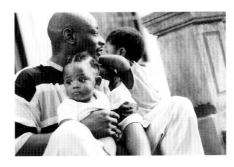

Lorenzo Smith, 35
DME (Durable Medical Equipment)
Technican
Born and raised in Long Island, NY
Naomi, Isaiah, Lorenzo-Tuari, and
Kievan-Joseph

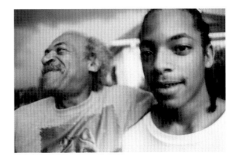

Dwight (Jackie) Dockery, 63
Retired Teacher
Born and raised in Philadelphia, PA
Kenisha, Dwight Kenneth, and
Keith Sinclair

Samuel L. Jackson, 57
Actor
Born and raised in Chattanooga, TN
Zoe

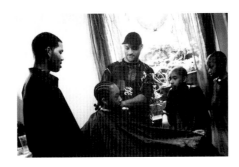

Danny Norman, 42
Middle School Teachers' Assistant,
Barber, and Poet
Born in Queens, NY, raised in NYC and
Denver, CO
Daniel T, Darrell Maurice, Dominique,
and Devanté

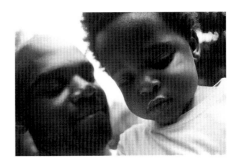

Noel Anderson, PhD, 35
College Professor
Born and raised in Brooklyn, NY
Avery Lloyd

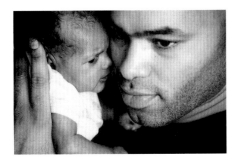

Jason Perez, 32
Aspiring Film Director
Born and raised in Bronx, NY
Jaxon

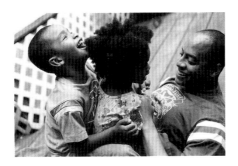

Bruce J. Williams, 38
VP US Equity, JP Morgan
Born and raised in Chicago, IL
Jett Alexander and Lola Olivia

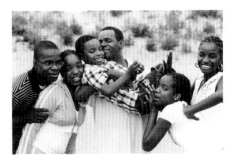

Stephen Jackson
Principal, Mount Vernon High School
Born in Rockaway, NY, raised in
Jamaica, NY
Malik,Tarik, Assata, Nneka, Akanke, and
Sekou

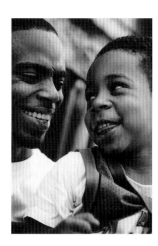

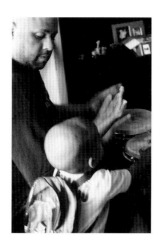

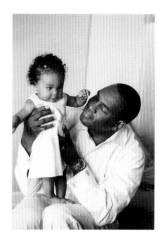

Nyron Isaac, 28
Construction
Born in Trinidad, raised in New York
Tyreeque

Munier Ahmad Nazeer, PhD, 39
Educator and Musician
Born and raised in Washington, DC
Muhammad Yusuf and Omar Takemura
Sulayman

Sháka Rasheed, 34
Institutional Investment Advisor
Born and raised in Miami, FL
Kira Iman

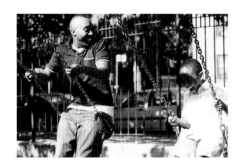

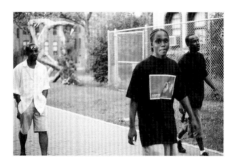

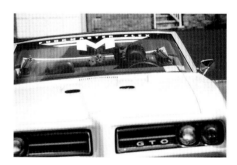

Maurice Marable, 37
Television Director
Born in Rantoul, IL, raised all over
Radiance Salem and Myles Maurice

Larry Patterson, 47
Entrepreneur
Born and raised in Queens, NY
Imani B. and Umi A.

Aston Taylor A.K.A. Funkmaster Flex, 38
Radio DJ and Television Personality
Born and raised in Bronx, NY
Jayden and Aston III (expected
November 2006)

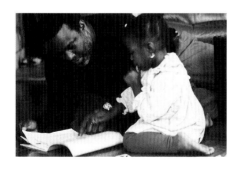

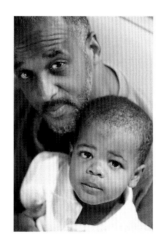

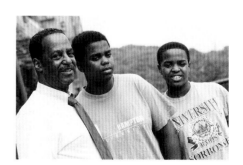

Jeffrey Charles-Pierre, 36
Architect
Born and raised in Queens, NY
Anayi and Kayenne

Sean M. Moss, 44
Government Executive
Born in Vicksburg, MS, raised in
Indianapolis, IN
Michael Callan

Ronald Cook, 60
Administrative Assistant to the Pastor,
Convent Avenue Baptist Church
Born and raised in Harlem, NY
Samuel David, Christopher Daniel,
Vanessa, LaVonne, and Ronald, Jr. (Kaza)

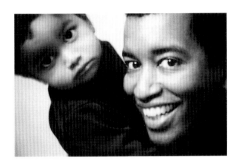

Amadou Diallo, 37
Photographer
Born and raised in Washington, DC
Rajiv

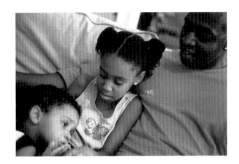

Frank Donalds, 39
Police Officer
Born and raised in Brooklyn, NY
Jordan and Aidan

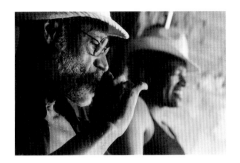

Melvin Van Peebles, 73
Author, Filmmaker, Playwright
Born in Chicago, IL, raised in Phoenix, IL
Mario

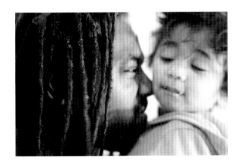

Nikon Kwantu, 36
Producer
Born and raised in Bronx, NY
Rakesh

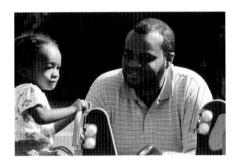

Juandiego Riccardo Wade, 40
Senior Transportation Planner
Born and raised in Richmond, VA
Gabriella Ruby Lee

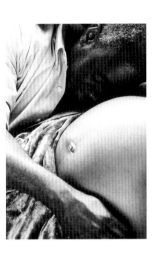

Mory Diarrassouba, 46
Designer
Born and raised in Abidjan,
Cote d'Ivoire, West Africa
Nala Khadi

Acknowledgments

The making of this book was a book in itself! I had no idea how many people it truly takes to get to its manifestation. Although I received many blessings and help along the way I must first acknowledge that this book would not have been without Shan Browning, who very lovingly and steadily *tricked* me into making it a reality. She took it upon herself to make sure it happened! She was there every single step of the way—believing, financing, guiding, telephoning, battling, crying, arguing, protecting, over-friending, uplifting and driving! Thank you, Shan. Here's to your pop, Lloyd Browning.

Thank you to the incredible team at Stewart, Tabori & Chang: Kate Norment, Galen Smith, Anet Sirna-Bruder, Maggie Kneip, Lisa Sherman-Cohen, and Sylvia P. Barnes. And to Joan Sandler, Joanne Fiore, Ron Urbach, J.R. Martin, Maureen Salandy, Hardy Rosenstein, and Nancy Leonard.

I would like to thank my editor, Dervla Kelly, whose expanded vision, passionate heart and exceptional fortitude believed in and maintained *Pop* from moment one. Thank you for snatching it up and pushing it in! Angels can be editors too, and without you, I just don't know. Thank you to Publisher Leslie Stoker, whose very kind, warm and wise spirit touched mine and embraced this vision.

Thank you to Tara Deveaux, Kenisha Dockery, Gayle King, Susi Yu, Chrishauda Lee, Stacy Bello, Sharon Norman, Stacey Jackson, Geeta, Lisa Bates-Moss, Venus Murray, Lisa Weems, Monica Taylor, Lisa Tweedy, Kevin Powell, Lys Wilcox, Lynette Richardson, Pam Robinson, Chava Collins, Cynthia Craig, Kierna Mayo, Laura Swanson, Marva Allen, Bridget Williams, Raquiba Bourne, and Lisette Gunn for making it all possible.

Thank you to Sam, LaTanya and Zoe for just being y'all—family! You are all incredibly beautiful people. LaTanya, thank you for *really* praying when I asked. Sam, thank you for sharing your life and opening your heart with total love and honesty. Zoe, thank you for your bright, bright light and keeping me laughing under stress.

James & Lyssy—ah hah, you didn't know I was listening! Thank you for being there from the beginning to love, encourage and support my photography as a career. Thank you Jim Megargee, Cornelia van der Linde, John Cyr and Vasiliki Kouvaris at MV lab for your incredible talent. You lovingly exposed each photograph to new worlds. Thank you, Susan Taylor for making time to guide us and bless this project and Deborah Parker for keeping us in line on that day. Thank you, Gretchen Trainor at Stinehour for your support, guidance, enthusiasm and education. Flora Kelly, thank you for your words of wisdom, cards of encouragement, short/cryptic emails and constant laughter. Thank you, Marcelle Mentor for keeping us sane. Noel Anderson, my brother, my consultant for life!

Thank you to all of the amazing fathers in this book. You have all made this a wonderful experience. Thank you for your belief, faith and patience.

And finally, thanks to many friends and family who always offered support, love and understanding, even when I didn't return phone calls. Thank you Jan Askins, Kim DeShields, Niema Ross, Deborah Coleman, Shenazar Roberts, Adrienne Harris, Rosalyn Berne and Suzan Wiggins for just being. Thank you, Juliet Root for listening throughout the whole process and providing such loving care to all of us.

Thank you to my agent, Marie Dutton Brown, for being my light in the fog. Your gentle guidance is the absolute best in the world.

And finally, thanks to my family, who endured this intense process with me. Thank you to my parents, Muriel and Roland, for always getting on the phone together to hear about every little, tiny, minuscule aspect of my life and actually really, truly caring about every little, tiny, minuscule aspect of my life! Thank you for my life, my freedom to choose and a childhood full of laughter. And mother, thank you for my first camera. Thank you to my son, Austin, who made the ultimate sacrifice in sharing his mama. Monty, you are my best friend and my soul mate. Through thick and thin, while "limping in," no one in this world has pushed my spirit to grow more than you have. And, after all, that is why we are all here. Thank you for our journey. Thank you for our son.